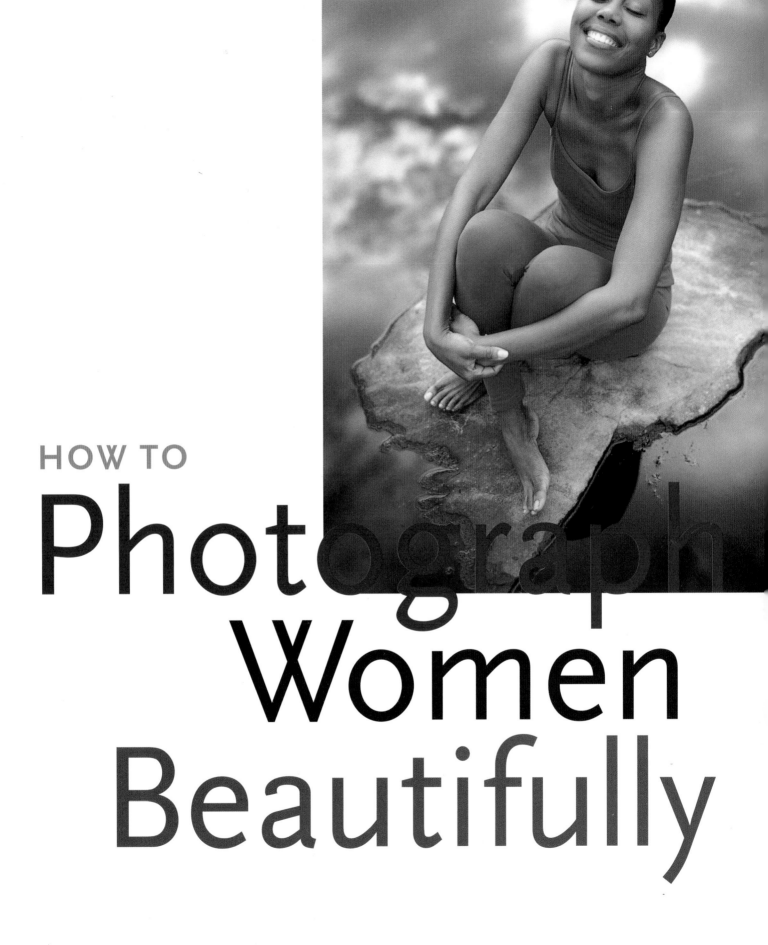

HOW TO
Photograph
Women
Beautifully

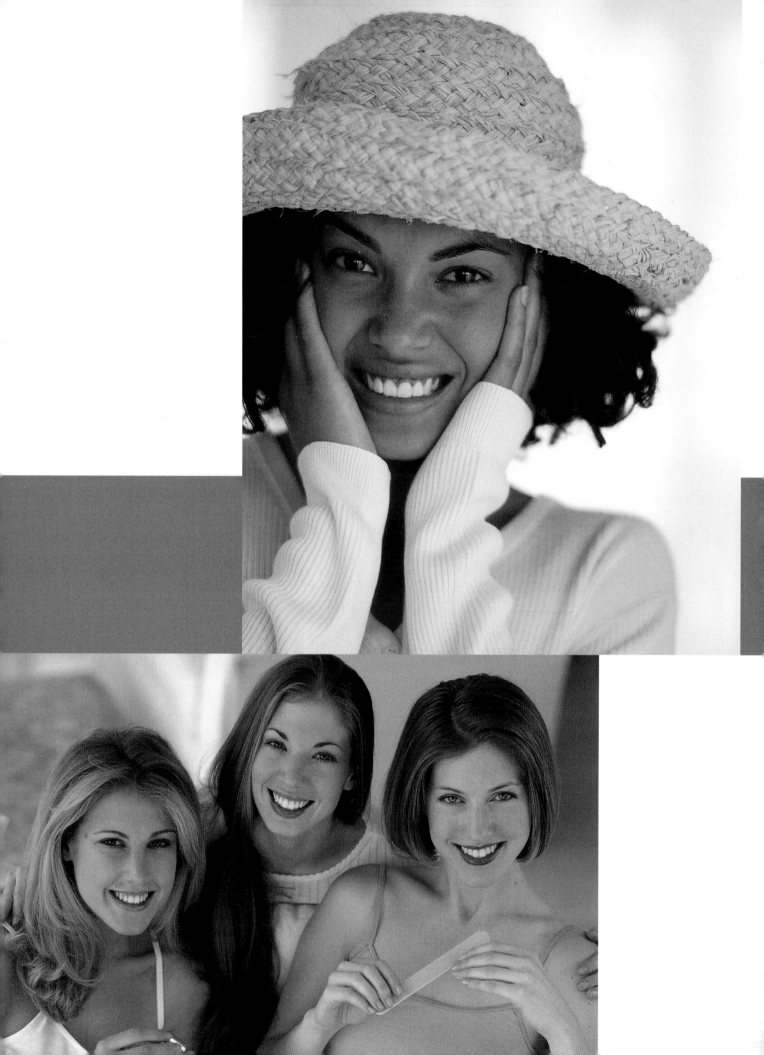

AMPHOTO BOOKS

AN IMPRINT OF

WATSON-GUPTILL PUBLICATIONS / NEW YORK

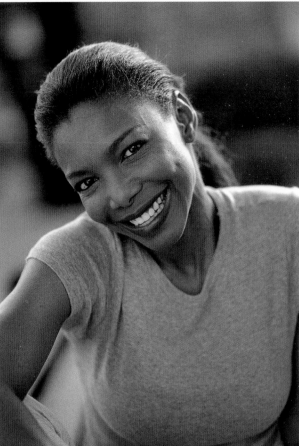

HOW TO
Photograph
Women
Beautifully

Professional Techniques for Creating Glamorous Pictures

J. BARRY O'ROURKE
AND MICHAEL A. KELLER

First published in 2002 by Amphoto Books, an imprint of Watson-Guptill Publications, a division of VNU Business Media, Inc., 770 Broadway, New York, NY 10003 www.watsonguptill.com

Library of Congress Control Number: 2002105813

ISBN: 0-8174-4018-6

Typeface: Scala and Scala Sans

Senior Acquisitions Editor: Victoria Craven
Editor: Amy Handy
Design: pink design, inc. (www.pinkdesigninc.com)
Production Manager: Hector Campbell

Manufactured in Spain

First printing, 2002

1 2 3 4 5 6 7 8 9 / 09 08 07 06 05 04 03 02

J. Barry O'Rourke can be contacted at jbofoto@earthlink.net
Michael A. Keller can be contacted at Mak1@voicenet.com

Contents

Introduction

Photographing women to make them appear beautiful is a very pleasant way to earn a living. Perhaps because I enjoy what I do, I am able to relate very easily to all the women I photograph. There is no great mystery involved in making someone look terrific, but there are plenty of practical considerations. People often think that the photographer's job is much easier when photographing a beautiful model, but just as much planning and thought goes into the composition of these photographs as any other kind. Your style in beauty photography is the result of how you work with both the models and the support team, and the results you draw from them as a group. Pulling together the right team is the most essential contribution you make to the shoot, but in the end you are also solely responsible for the result.

In actuality, there's not much to distinguish one beauty photographer from another. If you look through most of the women's magazines, it's difficult to pick out an individual photographer's work. We all tend to use the same models and hair-and-makeup artists. Most of the time the client is not looking for your personal style as much as for beautiful lighting, well executed and well exposed.

Although fashions and hairstyles have certainly changed since the first edition of this book was published fifteen years ago, with few exceptions the lighting and the general approach to beauty photography have not changed much. On a recent trip to a fairly extensive magazine store, I counted fifty-three women's magazines. Almost all the photographs showed full beauty lighting, clean with very few shadows. The exception was single-source lighting, usually with an HMI light or strobe with a six-foot umbrella, and several shots using ring light strobe. And, of course, since forty-five of these magazines had celebrities on the covers, quite a number had the paparazzo flash on-camera look—the least appealing. Available light has increased in popularity as art directors and editors embraced the natural look, although the majority of these shots had either strobe or reflector card fill. In other words, except for computer enhancement (I'm willing to bet that every one of those covers was run through Photoshop), not much has changed over the past decade and a half.

My coauthor, Michael Keller, is a former assistant of mine and currently one of the most prolific stock shooters in the business. I met Michael when I was giving a class at the School of Visual Arts in New York City. He was one of that small handful of students who make the whole teaching experience worthwhile. He worked with me for a short time but was anxious to get started on his own. Having decided to work with women as his subjects, he began the long road of putting together a beauty portfolio. This means testing with lots of young women who want to be models ("wannabes," as photographers call them). In exchange for their time in front of the camera, they receive photographs for their portfolios. Mike had the right idea: shooting constantly to learn the craft. He was fortunate to recognize early in his

career the phenomenal changes felt by the industry and the impact created by stock photography. No longer looked down upon as a last resort when the budget was inadequate to assign a shooting, stock has become a viable source for new and exciting images that are available immediately.

Eventually I realized it was time for a new direction. I closed my New York studio and built one in the country. I changed all my equipment from Nikon to Canon, Hasselblad to Mamiya 6x7. I got rid of my 4x4-foot custom-built studio bank light and changed my entire strobe systems. Most important, I increased my production of stock images.

Another big change occurred when I took a marvelous one-week course in Photoshop One at the Santa Fe Workshop. Expecting to be the old dude who held everyone back while struggling with a new mechanical medium, I was pleasantly surprised to find a number of students in my age range in our class of twelve. Reid Callanan has created a great atmosphere of learning and sharing and I highly recommend the workshop for anyone interested in either Photoshop or in digital work. Upon my return I added the Canon D30 digital camera to my bag of toys.

About the only thing I didn't change in all this was Carol, my wonderful wife, producer, and buddy! Carol and I have three children and three grandsons, all of whom have been used as stock models.

Through all of these career transitions, I have found a way to truly get back to photography, and fortunately I am able to work less and enjoy it more. Hopefully this book will help you increase your enjoyment of photography as well. As with so many other professions, to be good at photography you have to practice constantly. You learn something from every shooting. At first glance, beauty photography may appear to be simple, since what can be difficult about working with beautiful women? But each session is really a small production number. Hairstyle, makeup, wardrobe and accessories, background, film size, and layout (space for the magazine logo and cover blurbs) must all be taken into account, not to mention such considerations as what the model likes for lunch!

We will cover the technicalities of camera equipment, various lighting sources, and film emulsion choices. We will explain the basics of the beauty makeover, then explore photography of both "real" people and professional models. We will compare some images made at the same time with both film and digital cameras. And we will examine commercial and editorial aspects of beauty photography. We hope to touch on most of the situations that any photographer interested in working with women as his or her subjects is likely to encounter.

—J. Barry O'Rourke

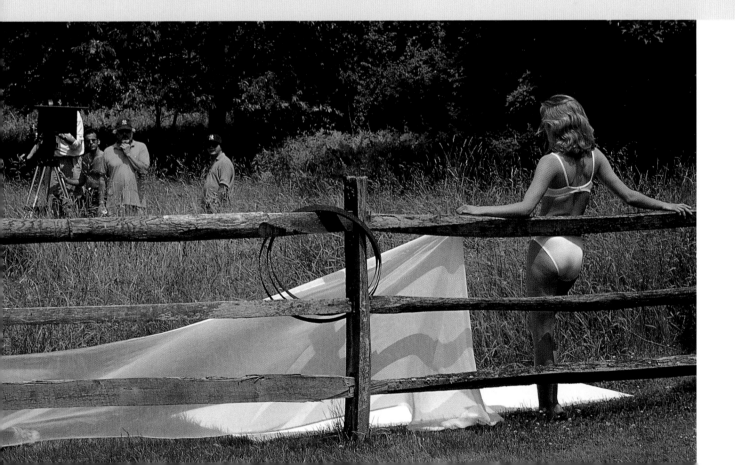

When I was about nine years old—long before the age of one-hour processing, high-speed color films, and digital cameras—I remember anxiously waiting to get my black-and-white photos back from the drug store. How exciting it was to see if any of the photos had come out. Well, that bit of excitement and anticipation hooked me forever. When I was in my early teens, my dad gave me his old 35mm camera, and soon after that he brought home his brother's old enlarger, some developing trays, a safe light, and a film development tank. I immediately took the clothes out of my walk-in closet and set up a darkroom, which became my creative workplace for the next seven years.

I became a voracious shooter, photographing my friends by day, then staying up late into the night making prints in the darkroom. In my spare time I read photography magazines and sharpened my darkroom and shooting skills. An art teacher at my high school, impressed with my photographic ability, offered me a gallery showing at the school. The show received a huge response from faculty and students alike, and the next year the school set up a darkroom and offered a beginner course in photography.

After high school I took some night courses given by professional photographers and editorial photo writers. The first course I took was given by Ed Meyers of *Popular Photography* magazine on achieving photographic print quality. For a final project we had to shoot a picture essay on a chosen subject. Since I was driving a coffee truck at the airport during the day, I decided to photograph the cargo workers, pilots, and airplane mechanics I encountered. When our picture essays were evaluated by guest speaker Willard Clark from *Camera 35* magazine, Clark encouraged me to show my essay to his picture editor. Five months later *Camera 35* featured a two-page spread, renamed "Coffee Cart Candids."

Ed Meyers proudly showed my published photos to his fellow colleagues at *Popular Photography*. Fellow editor and photographer Bob Schwalberg told Ed to have me bring in my portfolio right away. The very next day, Bob introduced me to the entire editorial staff, saying that I'd be available to illustrate photo articles for them. Life is funny: one day I was reading the magazine and the next day I'm working for them.

Having made this job connection through a photo course, I decided to take a course on commercial studio photography given by J. Barry O'Rourke. After the course I was delighted that Barry invited me to become a second assistant. I imagined

photo by Yvonne Bassett

myself setting up lights, taking Polaroids, loading cameras, and rubbing elbows with celebrities, but in reality I spent most of the day making prints from a previous job. I only saw the light of day when I was told to pick up the lunch from the caterer and run halfway across town to pick up a prop. Not very glamorous, but I didn't care: I was now a professional assistant. Little by little I was allowed out of the darkroom and given more responsibility on the shoots. I can't tell you how much I learned in the short amount of time I actually assisted Barry.

Serving an apprenticeship is one of the best ways to get involved in photography. You can read books on the subject and study in the best schools, but there is nothing like actual hands-on experience, especially if you have a great teacher like I had.

A year after working with Barry, I was determined to set up my own studio. Since I couldn't afford the rent by myself, I asked three photographer friends to share the space. After three months of

sweat equity we had a newly remodeled studio to call our own—a place where we could perfect our craft and make some money. I continued to work for *Popular Photography* and began shooting small assignments for women's magazines and catalog houses. In a short time I was working with some of the most beautiful women in the business, illustrating articles on exercise, nutrition, makeup, weight loss, hair, skin, and nail and foot care.

As my career progressed I began showing my portfolio more often in hopes of receiving new work and making connections. I remember the frustration of coming back to my studio after a full day of showing my portfolio without receiving a single assignment. Magazine and ad agency art directors were more interested in purchasing photos right out of my portfolio for editorial stories and ad projects they were working on already, rather than assigning me new work. That was fine, and I did manage to sell many photos during my portfolio showing, but how could I make a living selling just a few pictures a week? Yet it turned out to be a blessing in disguise that no one hired me. Little did I know that I was about to embark on a successful career as a stock photographer.

In the early 1980s my checks from the stock agency I joined in 1976 began to double. That was enough incentive to start shooting more stock photos. I started asking models to stick around after assignments to shoot stock. I would do shots that they needed and I could do shots that I needed. They would have access to all the shots to use in their portfolios. They signed model releases so I could submit the photos to my agent. The models loved it, since not only were they making money from the job we shot, but they were getting new photos for their portfolios with no cost to them.

By the mid-1980s as my stock sales rose, I decided to step up the pace and devote more time to producing stock. I started by doing small productions, buying inexpensive props and clothing and shooting two models on the beach all day. I would repeat the same scenario the next day with new models, props, and clothing in a different location.

The look of stock photography has altered over the years, and the technology used to capture, store, and retouch photos changes all the time, but the devotion photographers feel to their craft has not. My advice is simply to shoot what you enjoy shooting most and shoot it with passion. Since most of our waking lives are spent working, you should embrace whatever profession you have chosen with a positive, sincere, and loving passion. If you are genuinely passionate about your work, it may very well affect the size of your paycheck, and will certainly be reflected in how happy and balanced you are in life.

—Michael A. Keller

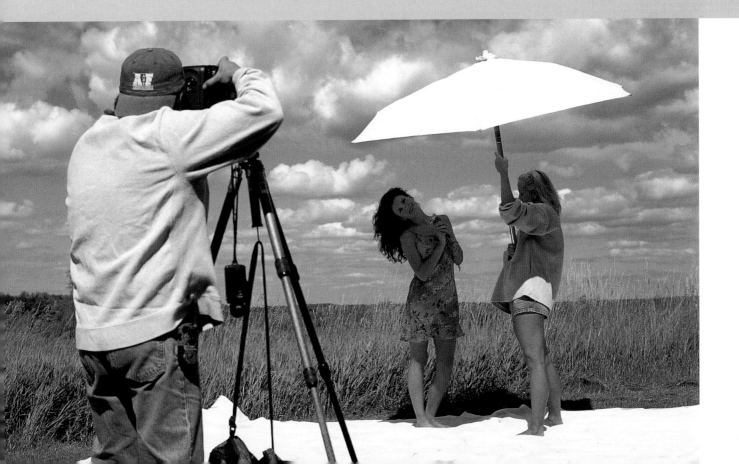

Preparing for the Shoot

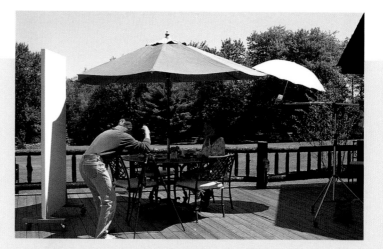

Michael prepares a beauty photography shoot in steps. He starts with the model, choosing someone who is not only photographically appealing but has personality, a pleasant disposition, and charisma. Selecting a model based solely on her portfolio pictures is difficult for two reasons. One is that she may be a new model whose portfolio is filled with photographs taken by a beginner that don't really do her justice. The second reason is that it is impossible to gage personality just by looking at pictures. You want your model to be warm, friendly, and enthusiastic. After you've established a working relationship with a good model, she may even have ideas to contribute about styling, makeup, lighting, and so on.

When meeting with a model for the first time, Michael looks at her portfolio, meets her in person, then spends five to ten minutes chatting about almost anything to get a sense of personality. With experience, you can usually get a good idea of what someone is all about in ten minutes. But take your time and choose someone who suits your own working style.

Next Mike considers background and light. On location he always looks for neutral backgrounds. These are generally simple, uncluttered, and light, and must be in a spot where there is good light for the subject. Be aware of buildings or trees that may obstruct the sun, and remember that as the day progresses your light will change. A background that works at noon may not be suitable at 5:00 P.M. When the light isn't happening anymore, it's time to pack up and move to a new location. Sometimes this is as simple as moving a few feet; other times you'll have to jump in the car with your equipment, models, and support crew and drive several miles to another location. At times the changing light can inspire a completely different shot than the one you began working on. Always go with your gut feelings, and switch gears if you have to so you don't miss an opportunity for a spectacular photograph that may never happen again.

Next comes makeup. Some models are good at doing their own makeup, but an inexperienced model may require the talents of a good makeup artist. Mike tends to go with a very natural look unless he's after a certain effect. You can see many examples throughout the book of what a big difference makeup artists can make in how the model looks.

Once the location is found and the model is made up, Mike chooses wardrobe that complements the model, makeup, and background. Because he shoots mostly stock, he tries to select clothing that is not so trendy it will be out of fashion in a short time.

With all in order, it's time to shoot.

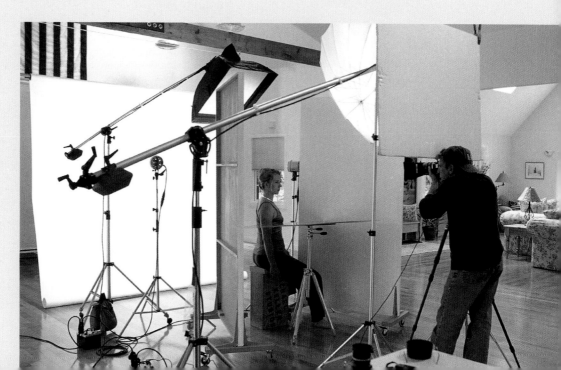

Equipment

Barry used to work primarily on assignment for ad agencies and magazines, frequently handling large productions. This required location shooting with at least three cases of equipment—perhaps more than fifteen—and meant extensive arrangements involving flights, cabs, limousines, location vehicles, hotels, meals, and everything else involved in the production of a major national consumer ad or ad campaign. He was used to "troop movements"; in fact, on one shoot he took thirty-one models plus the shooting crew on location for a week. Now he travels light. On an assignment for Dannon Yogurt to photograph three members of the U.S. Olympic Ski team in Denver (see pages 114–15), he took only a Mamiya 6x7 with three lenses and three magazines. He hired freelance assistants and makeup artists in Denver and rented everything else there, including a studio.

Barry would normally have shot digitally but the primary shot became a full-length "standee" in grocery stores throughout the country so he needed a fairly large image to work with. Rather than schlep a 4x5, he felt the 6x7 with Kodak E100S 120 film would be sufficient. He tends to use this film for at least 90 percent of his work, both in 35mm and 120.

It gives the skin tone he prefers without becoming too warm late in the day. When he wants something a little "gutsier" or more saturated, he uses E100VS. Once in while he will shoot Kodak Gold negative film and push it a half stop or more without compensating in the exposure. This gives an overdeveloped negative that can be scanned into Photoshop to blow out the skin tone while carrying saturated colors in the eyes, lips, and clothing. All these enhancements are much easier to deal with on the computer instead of through the traditional guesswork involved in bracketing and then waiting to see the results.

At one point in his career, Barry considered traveling light to be lugging five or six cases of equipment. Now with the incredible Canon zoom lenses available, he often takes only three lenses: the 28–70mm, the 70–200mm, and the 100–400mm stabilized lens, which covers a range of about six to eight fixed-focal-length lenses. He has started using the stabilized 28–135mm (a little slow at f3.5/5.6 but still manageable) and his new favorite, the 180mm macro. He has also been using Dynalites and several brands of soft boxes, with a 3x4 footer as a main light and several smaller ones varying in size. These are, for the most part,

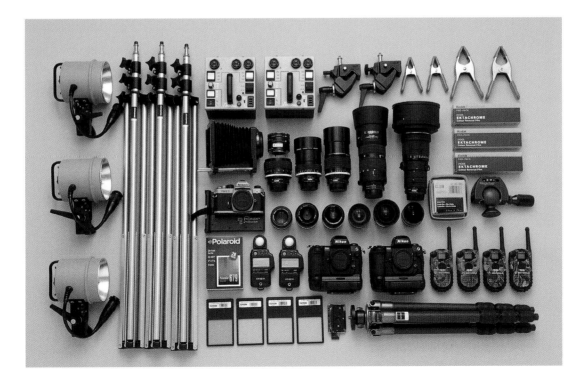

easily collapsible and transportable. The only piece of equipment he has not upgraded is the Polaroid 195, which was recently rebuilt by Polaroid; they are as hard to find as alligators in the subway.

One of Barry's friends keeps extensive notebooks with diagrams and Polaroids of everything he shoots in the studio. Barry, on the other hand, usually counts on memory, sometimes recording information on the back of the Polaroids (or in his agenda book, on a random napkin, or on a stray piece of paper which then gets misplaced). Try to develop your own good habits somewhere between these two extremes, especially when you start mixing light sources.

Michael prefers to shoot with available light as his main source. He has never been big on lugging heavy camera and lighting equipment through airports and to locations, preferring gear that is small, compact, and lightweight. Since he shoots mostly on location, he found shooting handheld quite a weighty burden and wound up using a tripod constantly because of the sheer weight of the camera and all the attendant equipment. After a full day of shooting, he always felt like he needed a chiropractic adjustment. With all the advanced technology and added weight that came along with the new breed of cameras, he had lost the freedom to move around his subjects. Finally he settled on the Nikon F100. Most consider it a step down from the F5, but he finds it a lightweight 35mm camera with a small auto advance, rewind, and enough professional features to make it a good choice. He was glad to be free of the tripod to enjoy the mobility again.

Michael has been shooting 35mm exclusively for the last ten years but still has two Hasselblad 2 1/4 bodies with a handful of lenses lying around the studio just in case a client demands it. On location he always carries two Nikon bodies and a Nikon FE as backup. He owns a 16mm 2.8, 20mm 2.8, 24mm 2.8, 28mm 2.8, 35mm 1.4, 50mm 1.4, 85mm 1.4, 105 macro 2.8, 135mm 2, 180mm 2.8, 80/200 zoom 2.8, and a 300mm 2.8. He never brings all the lenses on a stock shoot; his standard set on location is a 35mm, 50mm, 85mm, and sometimes the 180mm. When shooting an assignment, he usually brings all his equipment, just in case.

Surprisingly, he never uses the light meter in the camera. He learned from Barry that measuring incident light is a much more accurate way of determining exposure. To this day, even with all the advances in camera meter technology, he still uses a Minolta Auto Meter IV incident light meter for ambient and strobe lighting. An incident light reading of your model is reading the amount of light hitting the person, rather than the amount of light reflecting off her. People and their clothing come in different colors, and many times a reflective light meter can be fooled into thinking there is too little or too much light reflecting from the subject, resulting in an overexposed or underexposed photograph. Since the incident reading is extremely accurate and he is usually in close proximity to the subject, Michael never needs to bracket his exposures and hence he never misses a shot due to a bad exposure. But for some photographers, camera meters and spot meters do have their place, especially when you don't have the opportunity for easy access to your subject or are shooting with telephoto lenses. Experiment with metering technique and equipment until you feel comfortable.

Michael always mounts a Lindahl Bell-O-Shade on the lens he's shooting with. Not only does this keep extraneous light from hitting the lens, but it also has a filter draw to allow quick drop-in of gel or glass filters.

There are a few portable light-reflecting devices on the market today. Michael finds the Scrim Jim reflector to be an extremely lightweight, durable, portable unit that fits neatly into a 36x5-inch duffel transport bag. You can make either a 3x6-foot or a 6x6-foot reflector panel, depending on the size of reflecting surface needed for your shot. Even after taking abuse over the years, his units are still working perfectly. In addition to the white diffusion material that comes with the unit, you can purchase gold, silver, and black-and-white netting materials that can be easily fastened to the panels with hook-and-loop tape to change the reflectance, diffusion, or intensity of the light. One of Michael's most important pieces of light-altering equipment is a 5-foot white opaque tilting beach umbrella, which can be held over the model to soften the harsh light of the midday sun. A long extension pole helps get the umbrella high enough to provide coverage for two or three models.

After years of dragging around a heavy tripod, Michael finally splurged and purchased one made of carbon fiber. He finds the considerable expense of these tripods to be worth every penny when it comes to saving weight and setup time. He uses the tripod only when looking for precise composition and when using a slow shutter speed. He also uses a rotating ball head for quick camera positioning and a quick-release mount on top of that for speedy camera mounting and removal.

Years ago most commercial photographers were required to recreate natural light using strobes and render a scene in perfect 3400 degrees Kelvin color balance in practically every shot. Today a

more natural light of all color temperatures is in vogue. Preferring to shoot with available lights as much as possible, Michael uses strobes and other artificial light sources only when really necessary. Sometimes they can provide the only source of illumination, or they can be used to enhance the available light.

Michael always keeps handy two small 500-watt-second power packs, four light heads, six light stands, extension cords, super clamps, and a roll of good old gaffer's tape. He uses different-sized transportable umbrellas and soft boxes to soften the light and variously shaped reflector hoods, grids, and snoots to modify and shape the light. He also carries Rosco color-correction gels CTO 1/8, 1/4, and 1/2 for warming light; CTB 1/8, 1/4, and 1/2 for cooling light; and neutral-density gels to cut down light.

To check lighting, Michael uses a Polaroid MP3 back on a Nikon FE. This combination allows him to change lenses and see the image with the same

lens he will shoot with when using transparency film. He chooses Polaroid Polacolor 679 pack film because it matches the film speed of his transparency film and he finds it is a good all-around film for precise color rendition and proofing.

In his camera bag Michael keeps a small plastic container to hold 3x3-inch gel filters, a Swiss Army knife, a mini-mag flashlight, and lens-cleaning solution and papers. Because he finds it handy to have black tape around on all shoots, he wraps plenty of black masking tape around the container for quick access. A recent addition to his equipment list is four Motorola Talkabouts, which he can give to models or crew on location to stay in constant contact.

Since new equipment is being developed each year, take time to research all the new goodies that might be available. The Internet is a wonderful resource for this. The intelligent choice can keep you focused on taking great photos rather than on inferior equipment.

Begin working with simple lighting and slowly build your repertoire of techniques by experimenting with additional lights. Keep precise notes on distances, power for strobes, wattage for hot lights, exposures, and other additional information that will help you reproduce the same effect in future shots.

For further specifics on equipment and lighting, consult the captions of many of the photographs throughout this book, where you will find considerations such as equipment choices, f-stops, film speeds, and other information relevant to creating the same type of shot.

Beauty
Basics

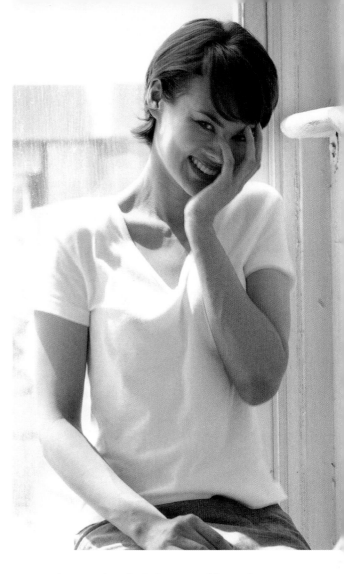

The basic tenet of beauty photography is to make someone look beautiful. You draw upon all your technical and mental expertise to capture that moment when everything comes together and your subject is projecting the image you want. It may take hours of preparation or it may happen spontaneously. You must be prepared to recognize that decisive moment and record it on film. Whether this moment requires a studio effort with a large backup staff or happens just between you and your subject doesn't matter; the end result is what you will present to the public.

Beauty is the general name given to this type of professional photography, but beauty is a natural quality. Glamour, on the other hand, is a created illusion. Yet beauty photography is largely a business of creating illusions, so distinguishing between the two concepts becomes a matter of semantics. The term *glamour* generally conjures up images of Hollywood stars, but to us it means a tight head shot for makeup or hair. Most women can be made to look glamorous but you must have something to start with in order to call someone beautiful in the most literal sense.

Most people do not study a face the way photographers do. When seeing models for a job it helps to engage them in friendly conversation and, while chatting, look over the face very carefully for minute flaws that might present problems. For instance, is someone's restrained smile hiding a crooked tooth? Also, observe whether they laugh readily, and relate easily to others. If you can figure out some of these things ahead of time, you can adjust for them before you begin shooting.

Beauty photographers look for many things when casting, but they are not necessarily looking for the perfect face. Casting people tend to look only at the complete package, but it helps to know all the individual elements of a person.

A successful beauty shot doesn't necessarily require loads of makeup or an elaborate hairstyle. But it does entail learning to recognize the moment when all the elements—model, pose, wardrobe, lighting, background—come together for a potentially terrific shot. Of course, a great makeup artist helps too!

The Makeover

Makeovers are a large part of the beauty photographer's business. Whether the subject is a professional model or someone without much experience, the styling procedure is basically the same. It's important to make those with less experience feel relaxed, and to encourage them to ask the makeup artist lots of questions. Although most women who come to a makeover are willing to try a new look, getting someone to change an accustomed style can be a problem. Stress that she is free to disagree with anything that makes her feel uncomfortable, but encourage her to have an open mind.

Professional models and celebrities are a slightly different case, but both ordinarily have a particular look with which they are most comfortable. Models generally accept any kind of appearance for a specific shot, as long as you don't cut their hair or do something they can't immediately wash out. Celebrities are concerned with maintaining the look they have nurtured over the years. Most insist on bringing their own hair and makup person, and it's usually best not to fight this preference. A satisfied, happy subject is a lot easier to deal with than one whose ego has been trampled upon.

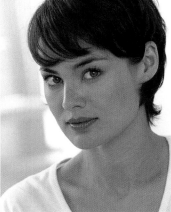

An assignment for an editor on a particular story means that the concept has probably already been worked out with the makeup and hair people. If not, discuss with these people what the final results should be so you can reach a mutual agreement based on what the client needs. But even when this decision is left to the photographer, the selection of a makeup artist becomes a very important factor in all beauty sessions. Most photographers have a group of people they choose from, depending on the requirements of the job and the artists' availability. These working relationships are developed through trial and error over the years.

Let the makeup artist suggest a direction based on the model herself and the parameters of the job. And try to use hair and makeup people who won't get bent out of shape if the client or account executive make a suggestion. The end result in choosing the makeup artist should be to create a happy team effort, because there's nothing worse than a reshoot—unless it's in the Caribbean!

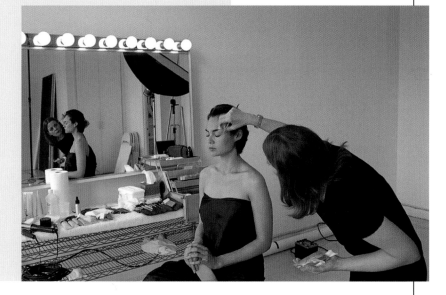

Barry shot this sequence using a Wafer 3x4-foot soft box with one Dyna-lite head at 500 watt-seconds. A broad bank of south-facing windows supplied fill, which was varied by shutter speed. In addition to available light, two heads were used, one aimed through an umbrella and the other bounced off the ceiling. The model is Nadia with Wilhelmina Models, and the makeup artist is Barbara Thies, who is using All Makeup by Mac.

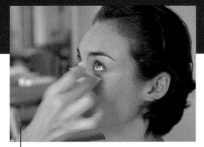

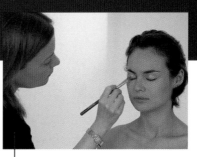

1. With damp sponge dipped into foundation and a bit of moisturizer, Barbara follows the contours beneath the eyes. She uses a lighter tone minus moisturizer along the chin and bridge of the nose and a deeper tone just under the cheekbones, along the sides of the nose, at the temples, and lightly down the jaw. The apples of the cheeks need just a veil of moisturizer.

2. Barbara opts for a pearly creme lid, which looks both fresh and polished. For contour she blends a taupe creme at the crease extending out and up into the brow area.

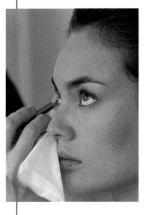

3. Using a prunella kohl pencil Barbara darkens the base of the lashes of the upper lid and the outer third of the lower lash line. Then she blends the kohl with a soft, short-bristle brush and cleans with the edge of the sponge. She fills in the brows with short flicks of a sharp taupe pencil and brushes to blend.

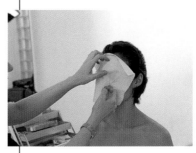

4. Since she has been working with tinted moisturizer and creme color, Barbara blots off excess oils. She finds blotting papers too hard on the skin, preferring a tissue separated into one ply. She rests the tissue against the face, lightly pressing into the contours.

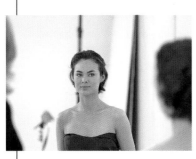

5. Barbara looks at Nadia in the mirror to check for balance. After working directly on the face, she find this change of perspective helpful. At this phase Nadia looks beautiful without lip color; a fresh application of lip balm or gloss would balance the soft yet defined eye.

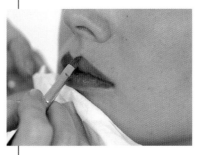

6. Barbara opts for added color on the lips, using a fleshy berry over balm at the fullest part of the lips, sketching the color in short dashes. With a brush she pulls the color toward the lip line and blends.

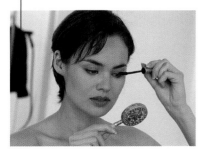

7. Nadia's naturally long, dark lashes don't require mascara, but she feels better with a light coat. To finish, Barbara checks for any blemishes and dark areas, using a fine detail brush to refine and blend a bit of concealer.

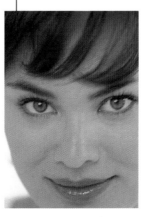

8. Finally, a light dusting of powder applied with a fluffy brush on the set completes a really fresh face. Here Nadia sat on the windowsill with the sun washing over her shoulders; a white fill card on the floor cut the glare from the polished white tile floor.

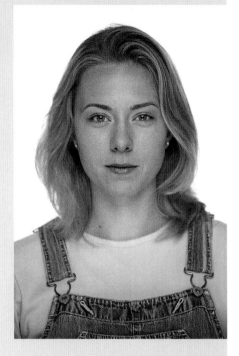

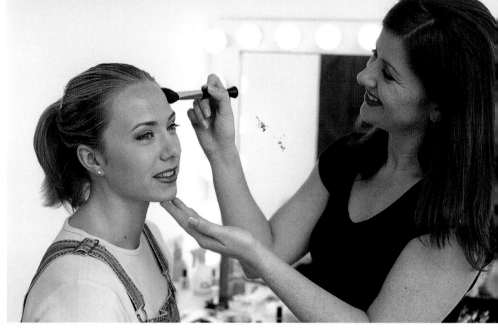

Model, actor, and singer Maria Grotpeter and makeup artist Leslie Banfitch, both from the Classic Agency in New Jersey, team up to work their magic. The before shot without makeup shows the dramatic impact a great makeup artist can have. The instructions to Leslie were simply to do her thing and make Maria look great.

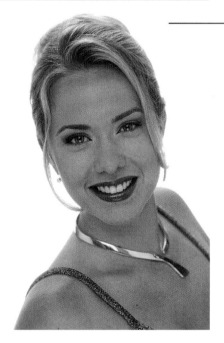

With the makeup complete, Michael set up a white seamless and aimed two strobes at the background. A small soft box with strobe mounted on a boom stand was positioned slightly behind and aimed at the top of her head. A 4x8-foot white flat on each side of the face provided additional fill. A silver show card on a tripod about 6 inches below the breast filled in under the nose and chin and gave the eyes more sparkle. The main light was another strobe on a boom stand, aimed through a large white umbrella. A large card clipped between two stands blocked the light from hitting the longer lens. This is a perfect example of classic beauty lighting, creating a soft, diffused light that reduces imperfections.

Lana wanted shots for her composite card. When the makeup artist called in sick at the last minute, Lana readily agreed to do the makeup herself. The photos shown OPPOSITE are good examples of what a model can do if she knows how to do her own makeup.

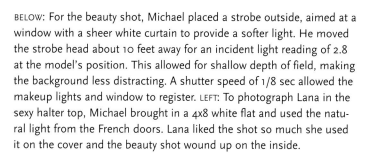

BELOW: For the beauty shot, Michael placed a strobe outside, aimed at a window with a sheer white curtain to provide a softer light. He moved the strobe head about 10 feet away for an incident light reading of 2.8 at the model's position. This allowed for shallow depth of field, making the background less distracting. A shutter speed of 1/8 sec allowed the makeup lights and window to register. LEFT: To photograph Lana in the sexy halter top, Michael brought in a 4x8 white flat and used the natural light from the French doors. Lana liked the shot so much she used it on the cover and the beauty shot wound up on the inside.

LANA

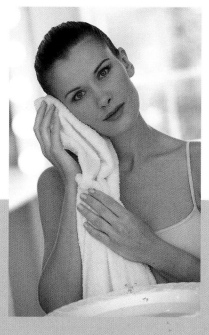

With the help of an off-white painter's dropcloth and a white beach umbrella (see the shot on page 9 for the setup), Michael transformed the harsh light of midday to a very pleasing diffused effect. A polarizer on a 50mm lens darkened the blue skies, reduced light reflections off the grass, and made the clouds stand out.

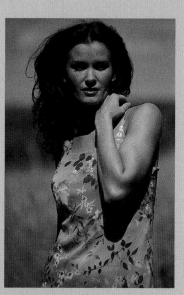

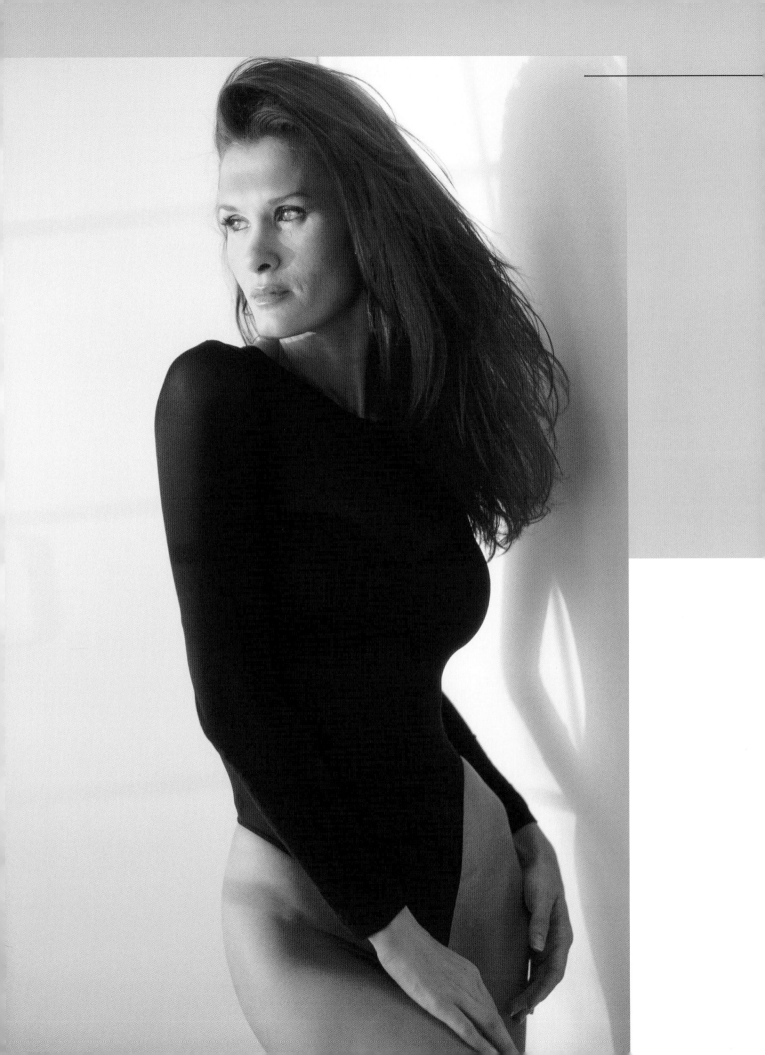

OPPOSITE: Lana and Michael were packing it in for the day when the sun came out from behind the clouds and bathed a portion of the studio in a beautiful golden light. With only a few minutes of sun left, he asked Lana to change quickly into the black body suit she had brought to shoot in. He moved two white 4x8-foot flats near the window to make a fast, simple background. He set the camera up on a tripod with an 85mm lens and E100S film and managed to shoot one roll of film.

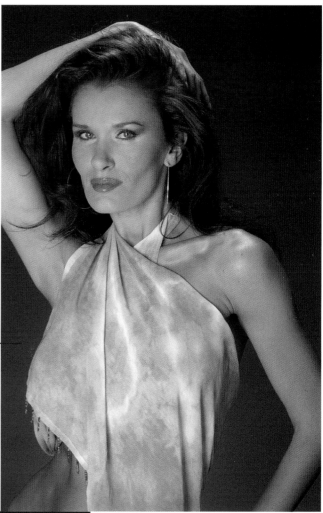

Michael placed a strobe with a purple gel about 5 feet away on the floor, aimed at the purple seamless background. A strobe light with a grid spot was placed on a boom stand up and slightly behind Lana, aimed at the top of her head. A strobe head with an 18-inch reflector pan with white diffuser over it stood to the left about 3 feet away, slightly below the height of her nose. Two 4x8-foot white flats reflect any stray light back on Lana, decreasing the contrast.

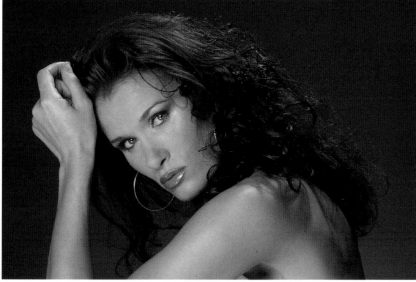

Lighting Options

Lighting is the photographer's primary tool. The more you study various lighting problems, the easier the job becomes. Remember that a great makeup job can't disguise lousy lighting. Practice photographing differently shaped faces to determine how to solve problems with lighting, using various camera angles or just having the subject turn slightly. Learn how to make all the features of a given facial structure come together as a pleasing whole in the final photograph. Study the effects of light on people all the time, wherever you are—at a dinner party, at the beach, in a restaurant. As a student of light, begin to catalog various combinations in your mind for use as starting points when you don't have a preconceived plan. For example, to illustrate a sunny morning, look for an east- or south-facing location to control the amount of light and color coming through the windows. Mornings are generally bright and cheery and late afternoons warm and soft, but there are many variables. Learn to be aware of these and understand how to work around them.

One advantage to working outdoors is the tremendous freedom from the encumbrances of studio lighting. You can just turn the model in the opposite direction for a different look. But this freedom has a price, because many of the problems that can be controlled in the studio manage to surface out of doors. The color will shift as the light changes, and you must control the harsh effect of full sun. And inevitably you're working at the wrong time of day to capture the look you want. Open shade is one of the most flattering lighting situations to photograph in. It is flat and even, and you don't have to use reflectors to fill any shadow areas. Thus it's one of the best types of light to look for when working spontaneously.

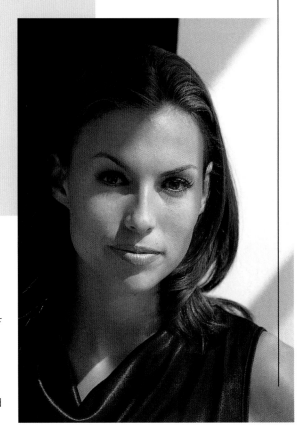

As a basic tool, the strobe is very useful. Although the strobe is balanced for daylight film, we sometimes have to compensate on a particular emulsion, either to warm it up or to remove too much cyan or magenta. Reflectors provide the crucial finishing element to any lighting situation, whether working outdoors or in the studio. They offer critical control over the direction and quality of any type of light, and can be used for anything from adding a highlight to a model's eyes to providing a subtle warmth in the overall tone of the photograph.

Tiffany, a Miami resident who commutes to New York for assignments with Wilhelmina Models, arrived with a healthy tan, making her a good choice for basic lighting with a 28–135mm zoom lens on the Canon 1V with Kodak E100S film. A Wafer soft box to the left of the camera was relatively high, enabling Barry to achieve a variation by simply tilting the head forward. The color on her face let him bracket the exposure by a half stop and still carry a pleasing skin tone. For the shot in the red dress, the afternoon sun washing a corner wall was the perfect place for a synchro sun exposure. With the strobe through an umbrella on the high left side (model's right), Barry used the minimum watt-seconds of 100 and let the sun become the main light, the strobe supplemental fill; the reflector card and white walls functioned as major fill.

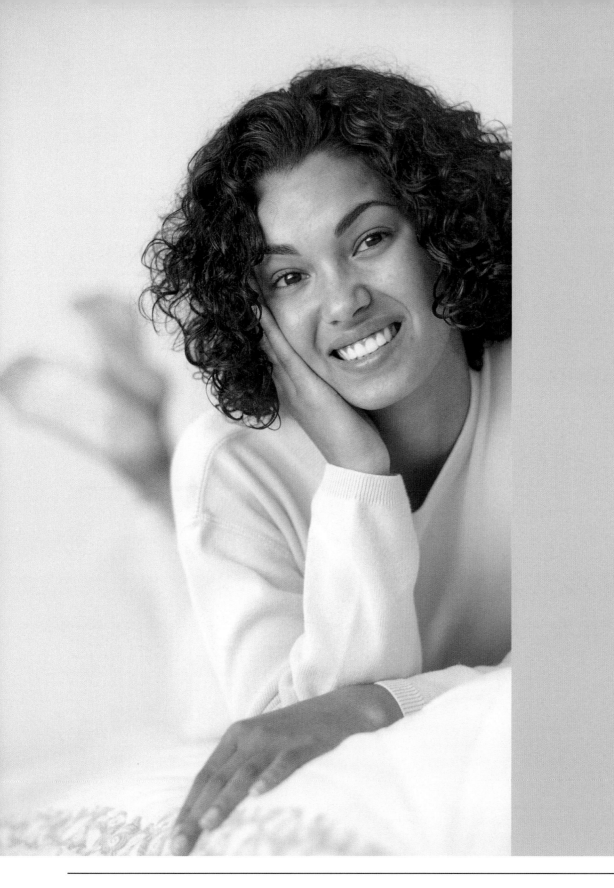

On a stock shoot in Miami's South Beach, Michael scheduled an early morning photo session. When the model arrived, the weather had taken a turn for the worse. Although it was sunny with bright blue skies, high winds of 40 mph made it impossible to shoot outside. Then Michael noticed the soft blue light coming through the north-facing windows. He directed the model to the window, where she looked beautiful. He cleared the background, grabbed a white sheet, and asked her to put on white jeans and sweater. He dropped a CC20B gelatin filter in front of the 85mm lens to enhance the blue light and adjusted the shutter speed to shoot at f/1.4 to keep everything but her face in soft focus. He chose Elite chrome 200 film and had it pushed just to be able to hold detail in her white sweater. Pushing the exposure to the edge can increase grain and helps wash out any imperfections in the skin.

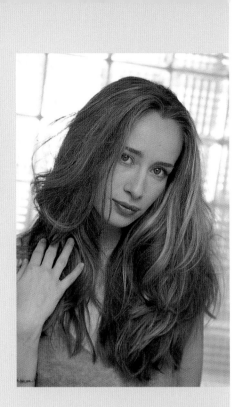

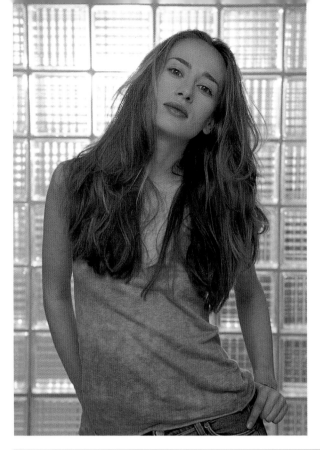

Barry captured Diana with a single strobe bounced off an umbrella placed directly behind him about 8 feet high, using low power on the strobe to allow the glass blocks to go soft. Behind the blocks, a 250-watt quartz light was aimed directly toward the camera, centered behind Diana. Barbara Thies applied light makeup for a natural look.

Simply by changing the shutter speed from 1/30 to 1/60, Barry was able to bring down the saturation of the glass blocks.

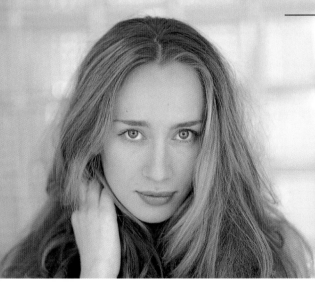

Turning off the strobe, Barry used just the light from the large south-facing windows behind him. Notice the multiple highlights in the eyes, which he achieves using three or four umbrellas to light up the whole face, lending a washed-out look that has been very popular in the fashion industry for the last several years.

By underexposing the image without changing any of the lighting, Barry achieved a completely different look.

This was Diana's favorite shot, totally natural and a little moody. Barry simply moved the setup closer to the bank of windows so they became one highlight source in the eyes. He turned off the strobe and quartz and let the bounce off the white floor do the rest.

Alex, who is also with Wilhelmina Models, has wonderful pale green eyes that seem to change color. Barry and Barbara decided to use the red lipstick to help emphasize the green in the eyes. The lighting was as simple as it gets with studio lighting: a single soft box slightly to the right and an umbrella lighting the background. A white reflector card was added on the lower left side.

A large soft box was placed camera right with a small (18x22-inch) soft box added to the left side. The strobe power was split evenly, with the large soft box one foot closer for a touch of directional light.

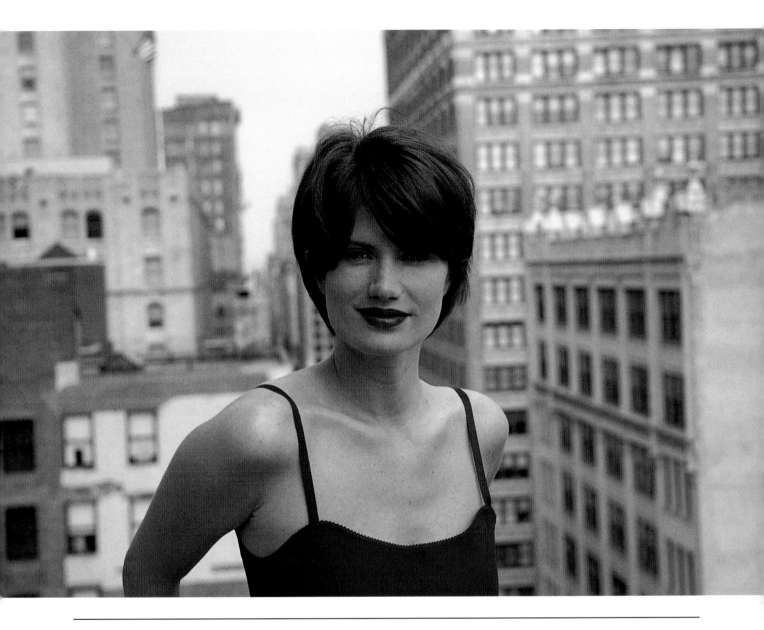

For a simple alternative to the studio shots, Barry had Alex step out on the south-facing balcony. The sky was bright but overcast—the kind of day that makes you squint no matter where you look. The assistant held a large white translucent umbrella in front of and above Alex and a dull gold reflector card was placed in front of her around waist level.

With Sara facing the windows, Barry used sunlight and a large white reflector card on her right side, shooting on Agfa Scala 200x ASA black-and-white slide film. This is a nice alternative during a shoot; when enlarged this film has a very nice grain pattern, tight and sharp.

Barbara gave Sara a very natural look and Barry placed her in the white corner of the studio with the windows on her left. He used a single strobe and umbrella placed a few feet above and directly in front of Sara, with a large white reflector card on her right. He powered the strobe down to 125 watt-seconds and shot at f/4 at 1/30 sec.

Two 4x8-foot boards of 1/4-inch white foamcore were taped together to form a right angle. Three strobe heads were then placed about 2 feet from the inside corner, 2 feet above each other starting from 3 feet above the floor. Basically Barry made an 8-foot-high bank light to create a daylight or north light effect, placed to the right of the camera. Another 4x8-foot sheet of white foamcore was placed camera left to act as a fill. Hair-and-makeup artist Ken-Ichi softened the makeup a little and added a touch of color above the eye to pick up the color range of the sweaters. This was shot with the Canon EOS 1V and the 180mm macro lens.

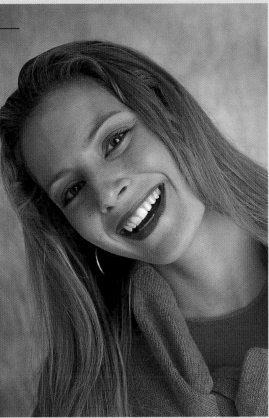

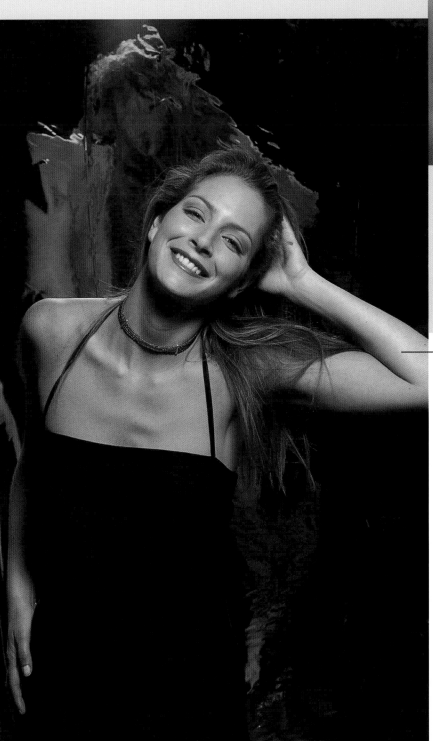

Trying for a fashion runway look with Stephanie from Wilhelmina Models, Barry put a small Mola dish on a Dynalite head mounted on a boom above her and hung a dark Mylar background. Ken-Ichi used an "out for the evening" look because he felt Stephanie's strong features could handle it nicely.

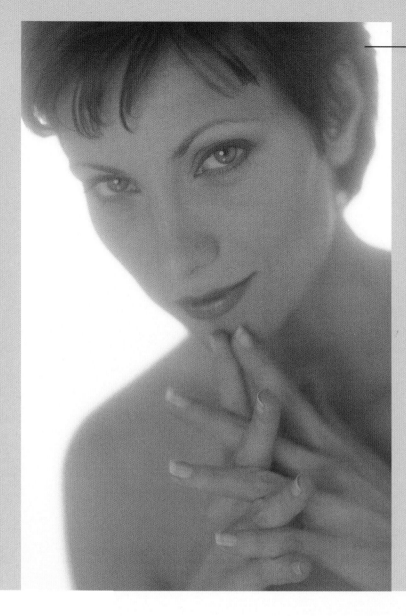

Here is an example of high-key lighting. Michael thought it might be interesting to incorporate tight and unusual compositions as well as Lisa's hands into a beauty shot. He made some suggestions but also let Lisa have some fun trying lots of different hand configurations. Two strobe heads were aimed at a superwhite seamless. A strobe head with a warming CTO 1/2 gel and a pan reflector with a white diffuser were placed approximately 3 feet away from Lisa. A CC10B gel and Tiffen Pro Mist 1/2 were placed in front of the 135mm lens. The camera was mounted on a tripod to obtain the exact composition. The warming gel added a golden color to her skin, and the CC10B gel combined with the pro mist 1/2 filter gave a cool edge flair around the head and body. The strobe head was powered down so Michael could shoot at f/2, giving very shallow depth of field and a softer feeling.

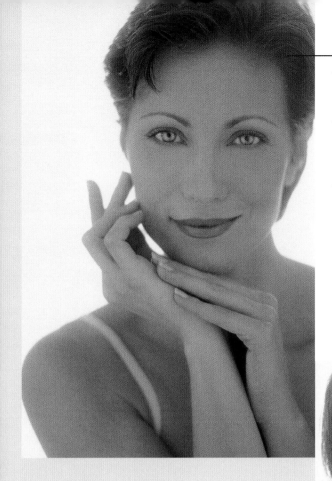

This high-key photo utilized the same setup as the photos OPPOSITE, but Michael removed the main light and all the gels from the camera and strobe lights and wheeled in two 4x8 foot white flats, one on each side of Lisa, placing them as close together as possible and leaving just enough room for the camera to see Lisa and not the flats. A white foamcore board was placed under her face to add more light. The light illuminating Lisa's face is bounce light, off the white seamless bouncing off the white flats. With this type of lighting you will usually get lens flare but this will add to the softness of the photograph, lessening wrinkles and skin imperfections.

Michael had Lisa put on a gold glittery turtleneck and changed to a lower camera position, an angle that proved to be very flattering. Once again he asked her to incorporate the hands, this time to cradle the face.

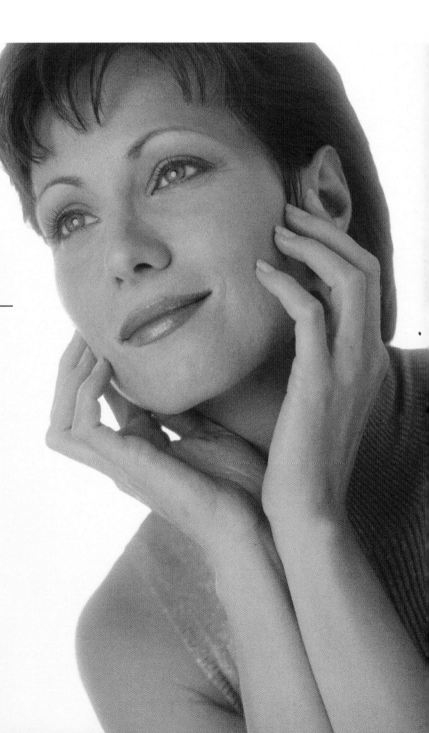

Keeping Pace
with the Trends

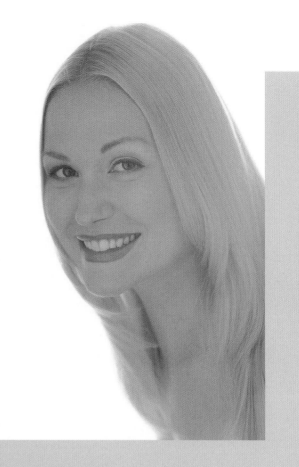

Today, the current direction in stock photography is toward photos that are soft, slightly overexposed, and not necessarily color correct. Agents may also request photos that are unusually cropped, such as cutting the face right down the middle, or photos that are slightly—or in some cases completely—out of focus. Not too long ago some of these types of shots would have gone immediately from the editing table into the garbage can; a year from now the shooting style will be something completely different. Traditional photography will always have its place in the market, and photographers who are able to adapt their shooting styles to accommodate the changing trends are the ones who will survive in this business. This continuing evolution opens whole new doors of creativity. Right now the trend fosters shooting portraits with wide-angle lenses, composing creatively, and using filters to enhance images. Photography has become fun again!

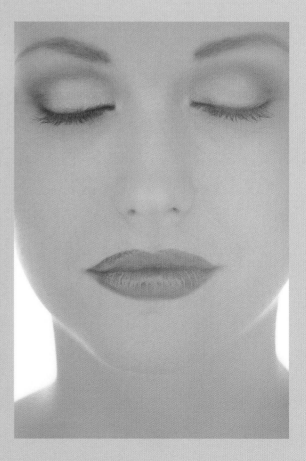

To accommodate his agency's needs, Michael planned a beauty shoot that would address today's trends. To achieve a very washed-out, overexposed look, he aimed two strobe heads at a white seamless background and used two white flats close to the face to fill in. The resulting images are slightly overexposed with some flare, which adds to the softness. He asked makeup artist Leslie Banfitch to apply Julie's makeup heavier than normal to compensate for the overexposure; otherwise it would look as though she was wearing no makeup at all. After a few shots of Julie with her hair down, he asked Leslie to put the hair up in a bun behind her head. He shot quite a few rolls of her straight on to emphasize her symmetrical face, then varied poses and changed compositions.

Stock Photography and "Real" People

Throughout their careers, Barry and Michael have worked with both professional models and with nonprofessionals, or "real" people as they're known in the business. For most jobs they prefer working with professional models, who make it their business to look good and dress appropriately, and they have experience working to the camera, taking direction, improvising, and generally knowing how to work with a photographer to obtain the best results.

Working with real people requires much more directing and patience on the part of the shooter. You have to make them feel at ease and instill confidence that you will make them look good. Since Barry started shooting more stock productions about ten years ago, he has found himself using friends and neighbors for situations in which he previously would have used pros. He had to put together a wardrobe to keep on hand when folks show up with dated or unsuitable clothing. He has found this problem increasing because so many clothes nowadays are covered with logos. You can remove these in Photoshop, but that can be very time consuming, and planning ahead is much more efficient.

Michael continues to use lots of real folks in his work. This can take a bit of doing since the photographer must be able to look someone over without being conspicuous and then make a judgment call about whether the person will photograph well and not become completely inhibited by the camera.

The look of stock photography has changed drastically since Michael submitted his first stock photos in 1976. Back then the formula was to photograph attractive fashion models wearing bright clothing and introduce lots of colorful props. Today's stock photography breaks many of the rules taught in photo school. Light, overexposed, cross-processed, blurred, grainy, even completely unfocused pictures seem to be in vogue. Michael's friend Roy Morsch

jokes that stock agencies have made their new picture requests so easy that all he has to do is get his models together, select a very slow shutter speed, click the shutter, and kick the tripod to wind up with images the agencies will adore.

Many stock photographers who have spent most of their careers creating razor-sharp, fine-grained, well-composed images may be hesitant to drastically change the look of the work that has previously brought great success. But this newfound persuasion to loosen up shooting style, wardrobe selection, film selection, and composition, and to integrate ethnically diverse actors and nonprofessional models has really been a breath of fresh air.

The following images serve as lessons both in shooting stock and in working with "real" people. To be highly successful in this business, diversification in various areas is very important. Stay abreast of cultural changes and capitalize on any new movement immediately. And keep your eyes open for new subjects all the time: some of the best models may be people you meet on the street, in a restaurant, or at a checkout counter. You won't necessarily find great success if your passion is solely to photograph beautiful women in sexy swimsuits. You have to shoot them as teachers, doctors, lawyers, health-care workers, athletes, home makers, grandmothers—the list goes on and on. Stock production does not always require a cover girl; sometimes it calls for the young mom, the busy exec, the happy couple—attractive but basically ordinary folks.

Amy Janroz was an aspiring model working as a nursery school teacher when she met Michael through a mutual friend. He recognized that she had the right combination of personality and looks, and helped her build a better portfolio.

Working Women

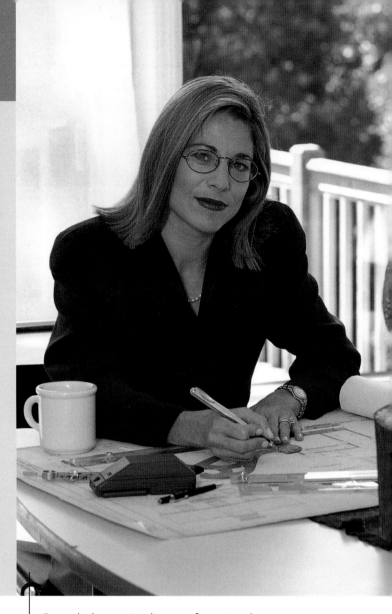

Successful stock photographers learn to maximize the output of different images during each session. Having an array of useful and up-to-date props on hand is extremely helpful in setting the stage for successful stock shots. Technology items such as cell phones and laptops are such an enormous part of our new electronic culture that they have come to be taken for granted, which also means they can be used in shots where they are not the primary product. A convincing workplace atmosphere does not necessarily require a lot of detail; even a plain tabletop placed over two sawhorses can make an effective desk. Wardrobe selection also has a big impact when seeking the corporate look.

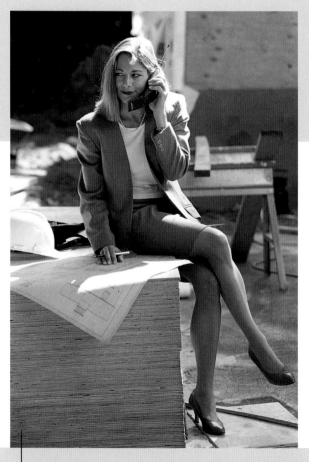

Formerly the creative director of a major ad agency, Markely often models businesswoman roles for Barry and is one of his regular "players" for stock shootings. On one occasion when he arrived for a shooting she was busy with some freelance design work. He told her to stay put and set up an umbrella at camera and a strobe bouncing off the white ceiling, then adjusted the speed on the camera to carry the outside.

In this shot made with early morning sun backlighting (the plans also function as a reflector fill), Markely could be either an architect or an engineer. When shooting stock, always be on the lookout for easy situations to capitalize on. Here Markely and her husband were adding a barn to their property, and the simple location offered many possible uses for stock sales.

Valerie Roy, a new model with the Thompson Agency in New York, wanted some test shots for her portfolio. At one point during the shoot, Michael grabbed a nearby cell phone headset as a prop. With the sunlight-filled window (covered by a sheer curtain) as the background, he placed two white cards close to each side of Valerie's face to provide as much fill as possible. He could have used a strobe light and white umbrella but he much prefers using natural light. 135mm lens; Elite chrome 200 film.

With minimal props, this photo manages to evoke a corporate setting. The phone, the background figure holding a file folder, and the subject's clothing all clearly say "office." Model Leigh Lombardi suggested the outfit herself, since many corporate women now wear men's ties and collared shirts. Michael stretched a white sheer curtain over the window with a single strobe head outside, aimed at the window. Two 4x8-foot flats placed as close as possible on each side bounce light back to her face. A CC20 B gel filter shifted the color to the blue side. 85mm lens at f/1.4; Elite chrome 200 film.

Barry's wife, Carol, discovered Lynn managing a gift store. She had already done runway modeling for department stores and was interested in posing for him. In this synchro sun exposure, Barry surrounded Lynn with white cards and used a strobe through an umbrella at 200 watt-seconds, so that the entire setup appears to be lighted only by the sun.

The Businesswoman Biker

Kimberly Ahlum is a successful business-woman with her own interior design business specializing in yacht interiors. She is also ranked 20 overall out of 400 expert-level motorcycle racers in her region and hopes to become the first woman rider in the World Supersport Tour. Barry drove up to New Hampshire to shoot Kim in two races at the NASCAR track in Loudon. Unfortunately Kim had dumped her bike at 88 mph that day and could not race the next day. Luckily she wasn't seriously injured and Barry still managed to get some great shots.

Barry turned New York hair-and-makeup artist Ken-Ichi loose on Kim, who generally wears very little makeup. Such women tend to have very mixed reactions, usually toward the idea that they would never wear so many cosmetics, but they always enjoy the experience. Overall, Kim was pleased with her new look, but decided she was more comfortable with a less dramatic appearance.

Kimberly needed a business shot for her design company. To the left of the camera at about 6 feet from the subject, a Plume bank with 800-watt-seconds was aimed through a 48-inch silk for additional softness. A 200-watt-second strobe bounced off a large white reflector card and through a silk for very subtle fill from camera right. The painted backdrop was also lighted with 200-watt-seconds.

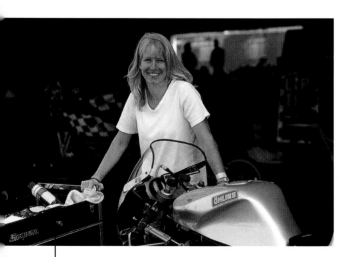

Kimberly pauses for a shot while working on her motor-cycle in the pits. This was shot in open shade while a helpful racer held an event poster white side out as a reflector on Barry's left.

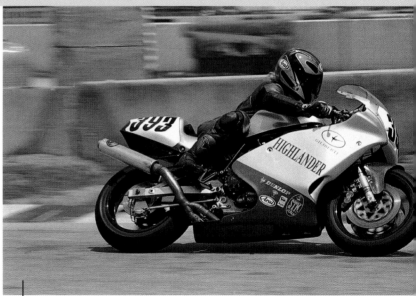

Kimberly in action on her grand prix Ducati, cornering at about 100 mph. Since Kimberly had injured her back, Barry couldn't shoot her on the track, but luckily photographer Christopher Vietri was able to supply this dynamic shot .

After the sedate business pose, Barry and Ken decided to do something different. Using the same main light, they added an umbrella to the strobe head at camera right, boosted the power to 500 watt-seconds, and added a large dull silver reflector card in front. A 200-watt-second bare bulb was placed directly behind the head. A one-stop blue gel over the strobe head lit the blue background, with a wide-angle reflector about a foot from the paper.

In the Gym

The gym in the corner of Barry's Connecticut studio serves two purposes: its facilities are greatly appreciated by visitors and clients, and the area makes a terrific setting for pictures. Each time he photographs there he tries to shoot it a little differently in order to maximize the production value from the various pieces of equipment. The rowing machine, treadmill, stationary bicycle, and professional boxing speed bag all make great props for photography sessions.

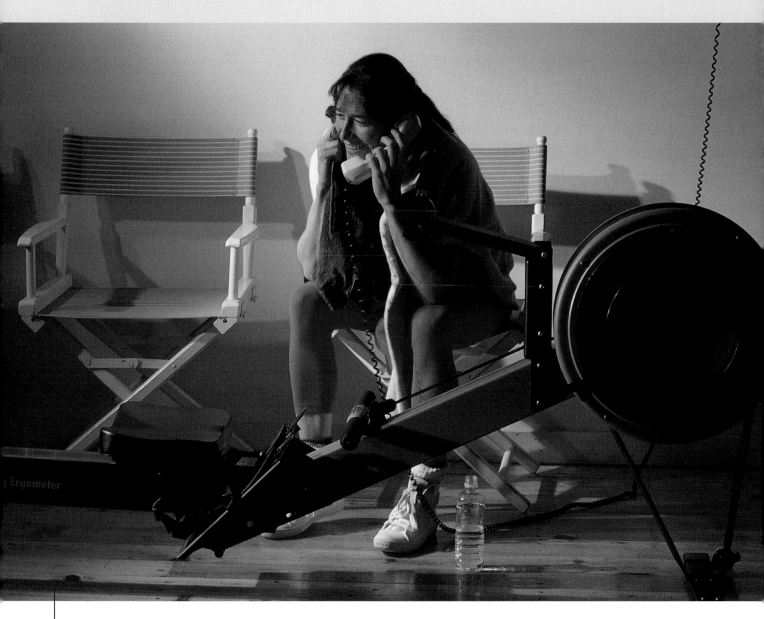

Barry's daughter Cindy does not like to be photographed, but he catches her nevertheless during a pause in her workout. A 1200 watt DeSisti HMI light and a Dynalite strobe were set up as close together as possible as a strong sidelight. A plus-one CTO warming gel was added to the HMI to create a early morning lighting effect.

Barry's neighbor Katrice tries out the gym. ABOVE RIGHT: In this dramatically shadowed image the figure is backlit with just the HMI light and no gels.

ABOVE LEFT: Thanks to the steady light source from the HMI, Barry is able to use the same lighting but a slower shutter speed to pick up the motion.

Katrice takes an exercise break to pose for a shot taken under HMI light only with a plus-one CTO gel.

Teenagers

Photographing teens can be tough. The first attempt is often unsuccesful, so count on several sessions as the kids warm up and shed their awkwardness. Barry's wife is always the first to approach the parents and is always present during these shoots. It's essential that a male photographer have a female assistant, wife, or girlfriend around when working with teens. And be sure to give the parents some flattering images!

Because in-your-face advertising has been very strong the last few years, wide-angle lenses are in again. Although the style may be hard to take at times, it seems particularly effective with teenagers. Barry photographed this neighbor with an old Asahi Pentax with a 17mm lens. Bought new around 1959, this was Barry's first SLR and he still keeps it specifically for this lens because it focuses down to 2 inches.

Michael spotted Hillary Martone working in the fish department of Whole Foods in Chicago. Her bright, bubbly personality seemed a charming complement to her beautiful green eyes and pink curly hair. She had never modeled before but was thrilled to be his subject for the day and agreed to bring some funky clothes, props, and jewelry to the shoot. Michael also gave her a few electronic props like this cell phone and let her have fun making a variety of expressions. To achieve a simple, out-of-focus background, he shot up from a low angle with a 50mm lens set at 2000 sec at f/4.

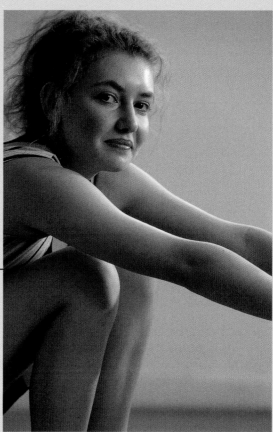

Katrin, who comes from the Dolomite Mountains in Italy, worked as an au pair for Barry's daughter Shannon. In these two shots taken in the studio gym, Barry used an overhead built-in bank of four Speedotron heads placed 23 feet from the back wall of the cyclorama and pointed at the right angle where the partial wall meets the ceiling. The heads were mounted equidistant from one another on a shaft running from wall to wall, each connected to a 2400-watt-second Speedotron strobe unit. A low power setting illuminated the room, with a soft box directly on the model.

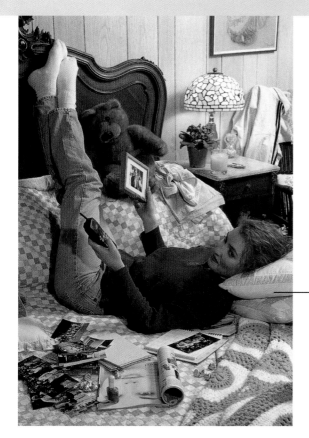

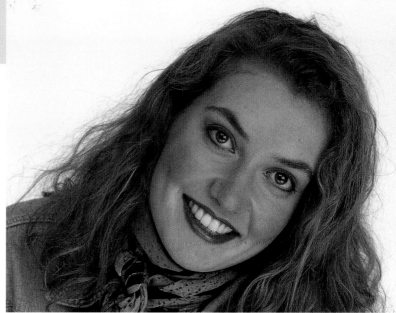

LEFT: Katrin takes time out to be a typical teenager. A combination of strobe and daylight with a slow enough speed enabled the lamp in the shot to register as on. Another strobe was placed at the camera at two-thirds the power of the main light, functioning more as a secondary main light rather than a fill. ABOVE: Katrin wanted a photo to send home to her boyfriend. She almost never wears makeup but decided here to add light mascara and lipstick. The shot utilized the built-in bank, the soft box for a little directional feeling, and a large dull silver reflector card.

Two Sets of Sisters

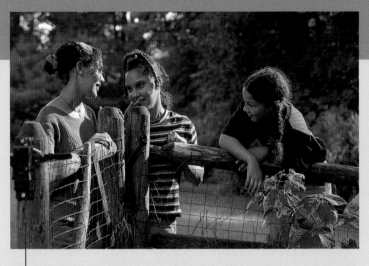

Once Barry and Carol became full-time residents in the Connecticut spot where they had been "weekenders," they figured it was time to check out their local talent base. Carol invited all the neighborhood kids to a Polaroid casting session. Barry ended up using all the kids and some of their friends over a ten-year period. He always paid them a small modeling fee. The mixed heritage of these sisters gives them a wonderful look and they photograph beautifully.

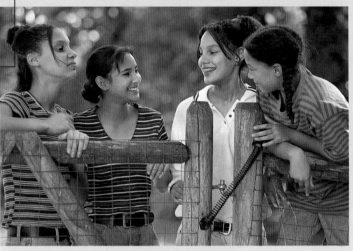

Barry has been working with these two sets of sisters from the neighborhood for a number of years, using them in various situations. ABOVE: The shot of three sisters in late afternoon light has a dramatic quality. RIGHT: Several months later, Barry's agency asked him to reshoot the same situation with the same kids in less extreme light. This later shot was made several hours earlier in the day than the first example, using an 81A warmup filter (very handy when shooting under green trees) while the assistant held a 6-foot white Flexfill reflector. The combination of fill and filter rendered the skin tones very neutral.

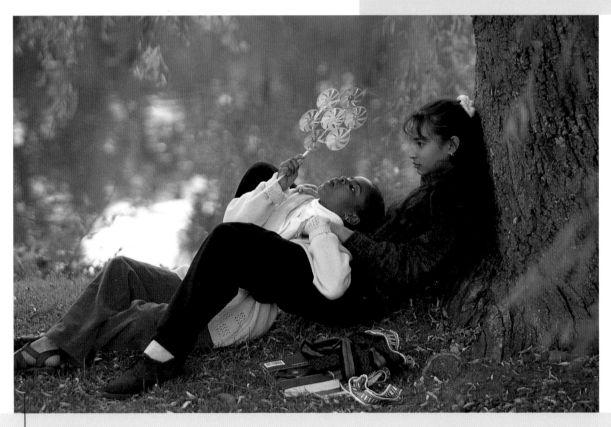

This simple backlit scene was shot along the banks of the Housatonic River, using the 81A warmup filter.

This girl's lovely smile really lights up her face. She posed on the town green, with a white card lying in the grass in front of her. The shot was taken with the Canon F2.8 70–200mm zoom lens on a Canon EOS 1N.

Here, the same Jamaican-American sisters are a few years older. This photo was also shot on the town green, using available light.

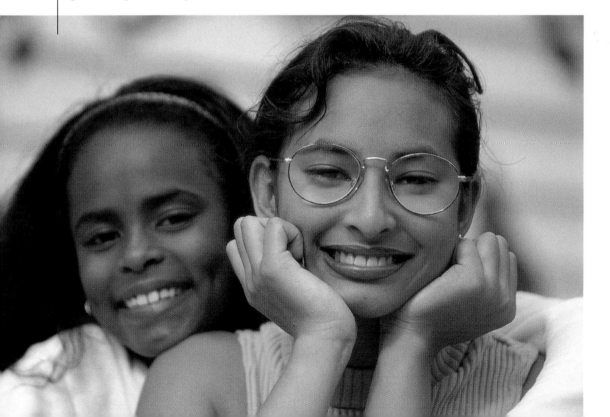

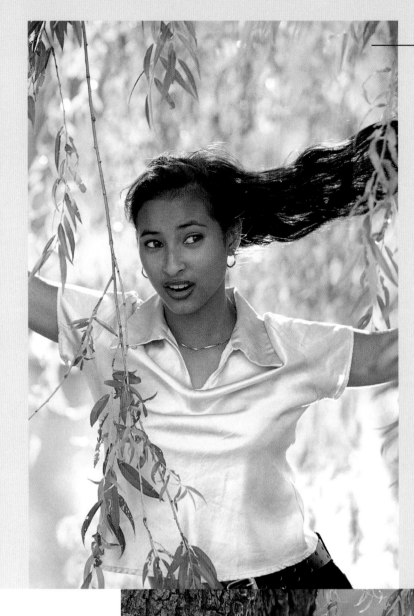

Barry took numerous shots of these Panamanian-American and Jamaican-American girls under the soft green of a willow tree. Over the past ten to fifteen years the marketing and advertising world has been more conscious about using minorities in more situations, something to keep in mind when planning a production shooting.

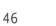

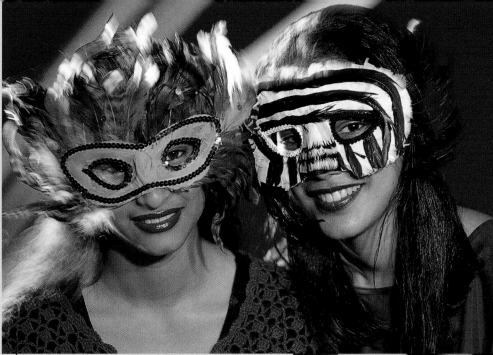

Barry's wife picked up these masks at a flea market and he knew they would be perfect props to illustrate the Brooklyn Caribbean festival. He used an umbrella direct at about lens level and an HMI light as a strong side light. He hit a red seamless with a red gel on the strobe, then placed three dayglow-colored foam swimming pool tubes in front of the background light but lighted separately with a spot adapter on the strobe. Everything was powered down so he could shoot almost wide open to throw the background completely out of focus. Using any "hot light" or tungsten light in conjunction with strobe allows you to set the camera speed slow enough to obtain a sense of motion.

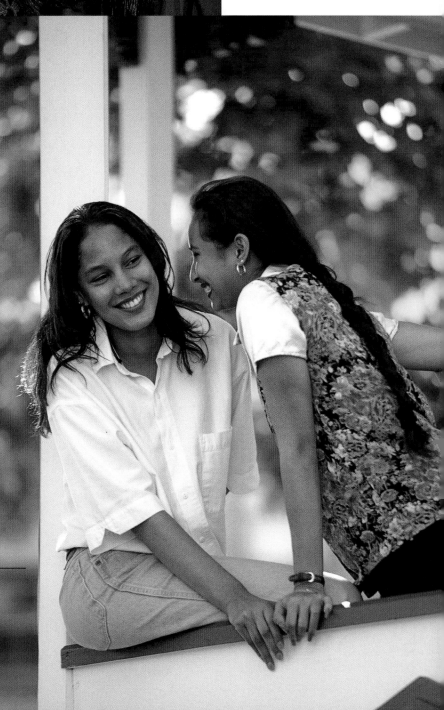

While shooting these seventeen-year-olds in the park, Barry told them to talk about their dates to his wife (who is standing off to the side) to make them more animated and a little giddy.

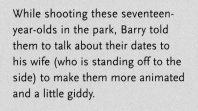

Mothers and Babies

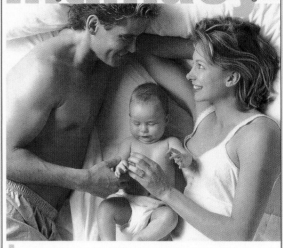

When it comes to shooting children for general stock shots, it's often best to work with nonprofessional talent. Generally you can find great kids through friends and neighbors; such children often bring a freshness and excitement to the shoot. Sometimes it's necessary to turn to a professional children's agency to find the right models. These agencies may represent hundreds of children of all ages and ethnic backgrounds. Michael has even occasionally taken out an ad in the local paper in search of younger models. People are always thrilled when they answer the ad and find out that the pictures will be free of charge, that they will be paid ten dollars an hour, and that there is a good possibility their child might appear in a major ad or national magazine if they sign a model release.

Keep in mind that no matter how polite and well behaved the little hopefuls may seem during the interview, that is by no means a solid indication of how they will perform on the day of the shoot. When you throw young kids into a studio environment with big equipment, bright lights, and strangers pretending to be Daddy and Mommy, most are a little unsettled and tend to become shy, introverted, and afraid—not a good subject for your pictures. Most commercial photographers have backup models waiting in the wings in case a child gets cranky and uncooperative. Shooting with an uncooperative child can be extremely frustrating and tiresome, and when shooting stock sometimes you must simply call it a day or move on to another shot that doesn't involve the child.

To avoid the frustration of working with an uncooperative child when on assignment, you can hire a "baby wrangler" to be on set to persuade an infant or young model to cooperate. Wranglers often show up with an array of puppets, noisemakers, toys, superhero costumes, bubble-blower guns, and all kinds of gizmos to help them get the job done. Working with a good baby wrangler can save you from having to make funny noises, silly faces, and endless promises.

Images of parents and babies are always in demand, both for advertising purposes and for editorial assignments.

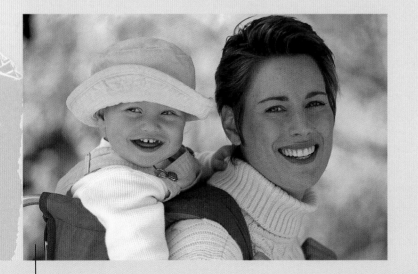

Michael's friend Harriet wanted pictures of her two-year-old daughter, Grace, for the family album. The same weekend model Kathy Murphy needed new shots for her composite card. When Michael spotted Grace's baby backpack, he got the inspiration to do some mother-and-daughter hiking shots for stock. The golden light filtering through the yellow leaves of a maple was the perfect warm light to shoot in, and the leaves shielded the models from direct sun and provided a lovely background. To add enough fill light he placed a white reflector beneath their faces. He shot with an 85mm lens on Fujichrome Astia film. Grace's mom stood next to Michael to help get Grace to smile.

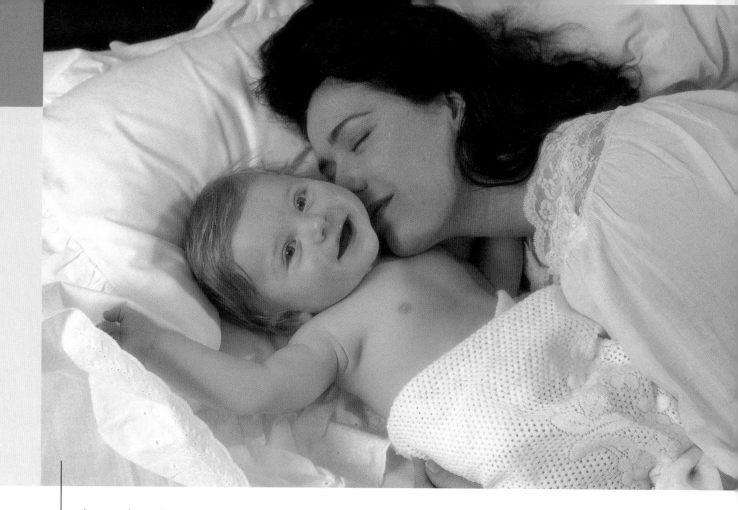

This was shot with a combination of two strobe heads with umbrellas. The strobe at camera right was at 600 watt-seconds and the one to the left, pulled back behind camera position, was at 400 watt-seconds. The main light had a 1/2-stop CTO filter between the head and the umbrella. Behind the camera were two windows; the overhead recessed room light was also turned on. The exposure was 1/15 at f/5.6 with an 85mm lens. The slower speed was used to allow a little ambient light to influence the color.

IF YOU'RE PLANNING A VACATION TO

IRELAND

BRITAIN

TRAVEL WITH THE MOST RELIABLE
AND EXPERIENCED TOUR OPERATOR

CIE **CIE TOURS**
International
EXPERIENCE · RELIABILITY · VALUE

US*TOA
$1 MILLION
CONSUMER
PROTECTION

CONTACT YOUR TRAVEL AGENT
OR CALL CIE AT 1·800·248·6832

Model Dawna Miller asked Michael to take some new mom-and-daughter photos for her composite card. After the shoot Dawna's daughter, Alyssa, asked to be carried. When Dawna picked her up, they both started laughing. Michael loved their happy interaction so he just let them have fun with each other, occasionally requesting that they look into the camera. The sky was gray in the original shot but the tour company that purchased it airbrushed the sky blue.

49

The Aspiring Model

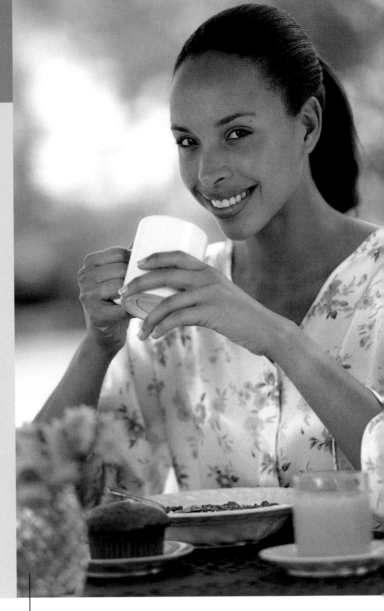

Working with a beginner model requires much more effort from the photographer than working with a professional. Beginners don't yet have the experience of seasoned pros and most of them need guidance on grooming, hair, makeup, posing, and wardrobe styling. They may need to lose weight, have a scar removed, change hairstyle and color, or mend an imperfect tooth. Some people may feel they are being picked on when they hear these things, but what they're really getting is valuable advice to help them further their careers.

Helping new models along on a shoot takes plenty of patience and constant praise, even when they are not giving you exactly what you want. Yelling at or demeaning a model in front of other people is just plain rude and will result only in lousy pictures and a bad reputation. Remember, most beginners are intimidated and nervous as hell, so you may have to shoot a few rolls to get them to relax before you can get some good pictures. Supporting them with gentle words will instill self-confidence, which is the key ingredient that models need in order to perform well.

An aspiring model should also have the self-discipline needed to take care of her body through diet and exercise, as well as a drive for success, because making it as a model is time-consuming, hard work. Someone who possesses all these things, plus a little bit of exhibitionism, lots of energy, some intelligence, and the right amount of good looks, just might have what it takes to make it to the top.

Since Michael was shooting an outdoor session with Valerie at noon, the harsh sunlight made it necessary to shield her by opening the patio table umbrella and by wheeling out a boom stand with white umbrella. He used a 4x8 white reflector to bounce light back to Valerie's face and proceeded to shoot her doing various things like drinking coffee and orange juice, eating cereal, taking vitamins, and finally working on a laptop computer. Once everything is set up, try to do as many different things as possible. Don't be afraid to ask your subject or assistant what the model might be doing in a given situation. Many times models and crew come up with excellent suggestions.

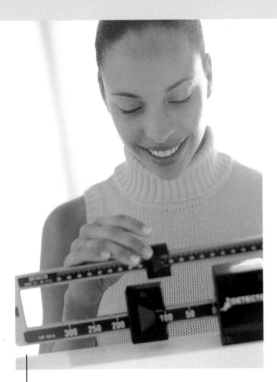

Michael found that he sold so many shots every year of women standing on weight scales that he finally purchased one of his own rather than having to keep renting one. This photo was taken with an 85mm lens.

Michael raises vegetables and flowers in his organic garden, which provides fresh produce all summer long and makes a wonderful background for photographs. (He even keeps sections of white picket fence around to set up in the garden for a more traditional, homey look.) After the shoot with Valerie, while they were picking string beans for dinner, the sun bathed the garden in golden late afternoon light. Michael grabbed a camera, gave Valerie a straw hat, and set up a white reflector. He shot a roll of E100S with an 85mm lens before the sun dropped below the trees.

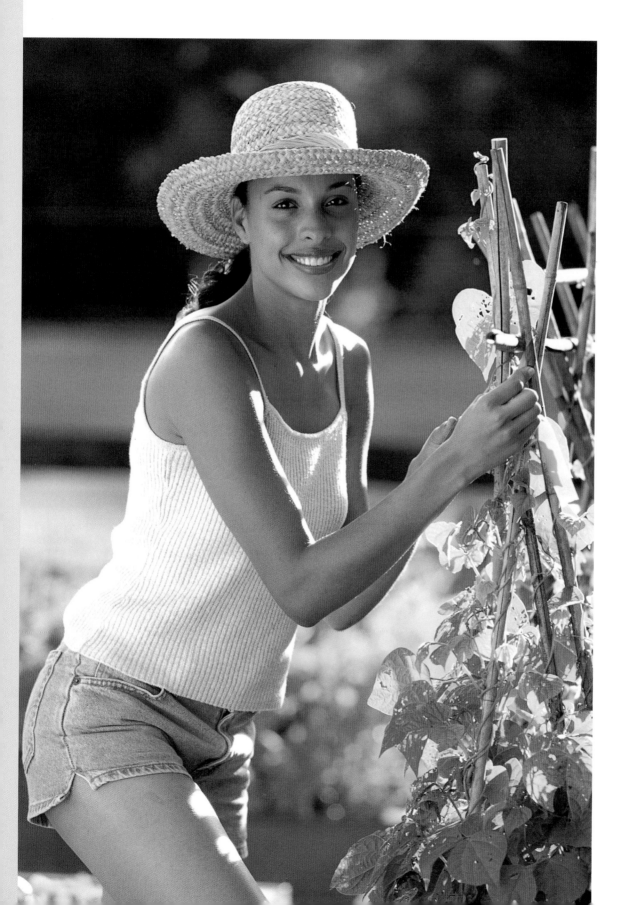

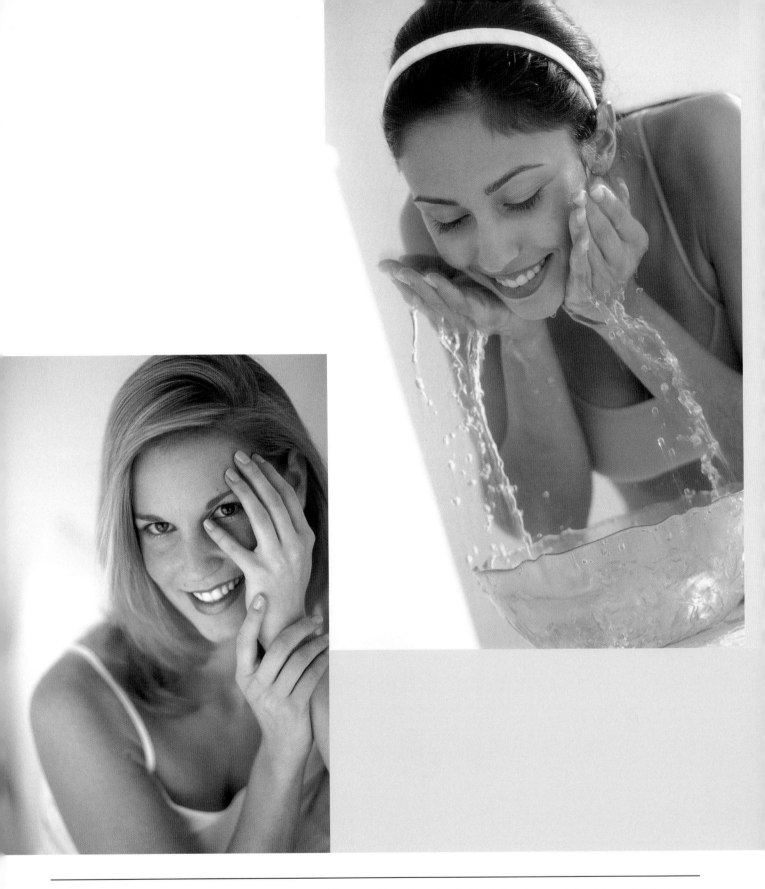

Janine Falsone went to Michael for help in starting a modeling portfolio. When they finished shooting portfolio pictures, Michael asked her to do some stock photos. Her beautiful skin, nose, lips, eyes, and profile made her a good candidate for some very close-up beauty shots. Michael wanted a sunny-looking series of Janine washing her face but it had started to cloud up. He placed a Rosco CTO 1/8 gel over a single strobe head, then took the strobe head outside and aimed it at Janine through the glass door of the studio. He placed two white reflectors close to her, one on each side, to bounce the direct light from the strobe back into her face. He also brought in a scrim to block the light from the strobe so it wouldn't cause lens flare in the camera.

To make this photograph, Michael covered the sliding glass door with a white sheer curtain for a background. Janine sat about 2 feet from the door, with two white cards close to her, one on each side of the camera, to reflect light back to her face. He loaded the camera with Elite chrome 200 film and placed a 10B Kodak gel filter in the filter draw of the Lindahl Bell-O-Shade to give the photo a cool look. He added a Nikon extension tube to the 85mm lens to extend the close-up focusing ability of the lens. Without this extension it's impossible get in this tight. Some photographers use a 105mm macro lens for close-up shots but he wanted the lens at 1.4 for the smallest depth of field possible. Slight flare from the sunlit curtain added softness to the photo.

After Janine put on a white camisole top, Michael handed her a spray bottle as a prop. He moved a white flat to each side of her face and dropped a Tiffen Pro Mist #2 filter into the filter draw of the lens shade, shooting with an 85mm lens and Kodak Pro Ektachrome 200 film for more warmth and increased grain.

The Model Type

Michael first met Christine Westlund when she was a hostess in the dining room at Club Med in the Bahamas, where he was working on assignment. After she seated him and his crew, he said to her, "I can't believe you are a hostess. You should be modeling." She remarked that she always thought of the idea, but like most hopefuls she didn't know where to begin. He replied, "Well, this is your lucky day. Meet me on the beach tomorrow morning at 6:00 A.M. with some swimsuits and I'll do some test shots for you."

The next morning Christine arrived right on time with her makeup done perfectly and an array of swimsuits. She was very nervous but Michael assured her that she was doing just fine and everything would come out great if she just followed his direction, which she did like a pro. In fact, she was so good that he worked her into his assignment shoot whenever her schedule permitted.

When he returned to New York and viewed the shoot on the light table, Michael discovered that her shots turned out better than those of the professionals he had brought along to Club Med. He sent her the slides and promised to start her portfolio. Six months later he received an assignment for the Sheraton Grand Hotel on Paradise Island. By sheer luck Christine called him the next day to say that she had left Club Med and would be starting a new job as a flight attendant. Michael said, "Pack your bags—I'm sending you a ticket tomorrow to be one of my models for a shoot on Paradise Island."

Two years later Christine invited Michael to Red Wing, Minnesota, to shoot her wedding. He agreed to shoot it for free as long as he could use the shots for stock. They were delighted and the wedding was beautiful.

Michael positioned a rented white van close to Christine's right for more even fill light. Standing on a rock, he shot down on her with a 200mm lens set at f/2.8 in order to get an even, clean background from the dry grass. He thought the colors of the grass blended nicely with her hair, shirt, and skin color. He composed the photo with room on the right in case an art director might want to run type over it.

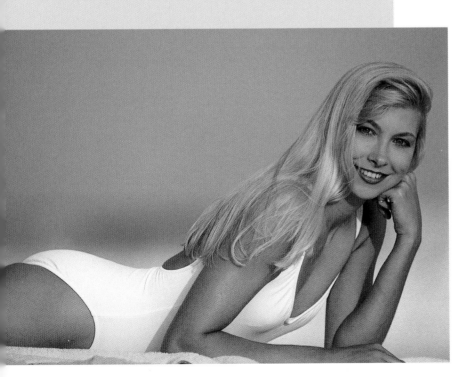

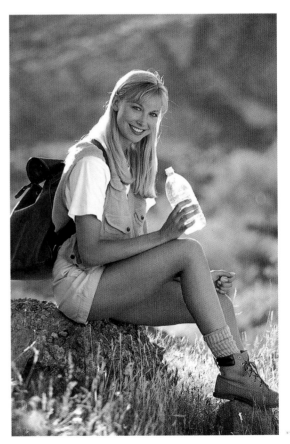

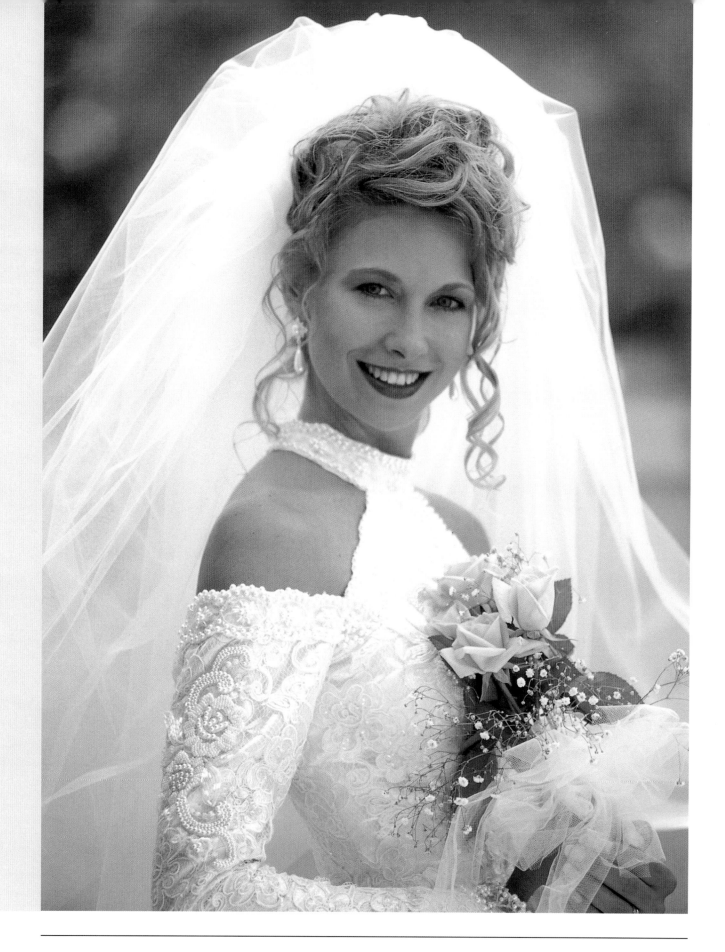

Despite the very hot weather, Christine looked beautiful, cool, calm, and collected. Michael wanted the pictures to look naturally lit so he used a large, round popup reflector rather than a flash fill. The reflector was gold on one side and white on the other; he chose this instead of a framed reflector because it opens and collapses very quickly and is extremely compact. He waited for a cloud to cover the harsh sun so it wouldn't blow out the detail in the white dress and veil. He used the round white side of the reflector to fill in her face.

Working with
Professional Models

Photographers use professionals to process film, they use professional assistants and professional hair-and-makeup artists, and they use professionals for production and set building. When it comes to booking models, they often prefer to use professionals there, too. There is a good reason the fashion and beauty industries trip over one another to use the same handful of supermodels: besides being trendy, they sell your product! Reality is for photojournalists, but photographers who work in editorial and advertising are in the business of creating illusions. Ultimately they are hired to help sell a product, to solve a graphic problem photographically, and it's often necessary to use as much professional help as possible to accomplish that goal. If you are successful, the client will return, and that is what keeps you in business.

Most photographers develop professional relationships with a handful of models that change over the years. But this is a very critical business, and as new models come along you may find yourself getting excited by a new face. Professional models are regular people from all over the world who just happen to be beautiful, tall, and slender and photograph well. What makes them professionals? As an art director once observed, "Models only have two responsibilities: they have to show up on time and they have to look good. The balance of the result is up to the photographer." This may be an oversimplification of the job, but it is to the point.

It's very important for the model to trust the photographer. Too many people feel they know their best angle, best expression, or best position of their limbs. They are more concerned about how each shot will look than with working together with the photographer. Photographers are in the business of creating a successful visual image. This only works when the subject is not inhibited and will follow simple direction. Even the best model won't look like a *Vogue* cover in every shot. Some photographs will catch a half blink or a partial smile, but you have to go through these to find out about the person you are photographing.

When working with a new person, many times the first roll is just a warm-up to discover who you are photographing in terms of facial and body movements. The easiest people to work with are full of self-confidence and have little concern about anyone's limitations—their own or those of the people around them.

Once a pro, always a pro: These women all modeled professionally at one time or another. Now busy with families and other careers, they still exude the confidence and ease before the camera that distinguishes an experienced model.

Capturing Movement

Many times when the photographer is searching for a solution using different body movements or expressions, the model is the one who solves the problem. When working with an experienced model, the first thing Barry does is show her the layout. If there isn't a layout then they discuss the purpose of the shoot: what they are trying to illustrate. He looks for participation from the models because they put more into it if they're excited about the end result. Too many photographers treat models as mannequins and the photos reflect that attitude. Models have to think about what they are doing to project the image you want. It also makes your job a lot simpler if you don't have to tell a model how to move in each frame. Most models are interested not only in how they will look but how the shot will turn out as a whole, and it helps to give them every opportunity to get involved.

It's not uncommon for inexperienced people, both models and photographers alike, to try to imitate a pose they have seen in a magazine or advertisement. All too often these shots end up looking very forced and awkward. The photograph they are trying to copy was most likely arrived at through a collaborative effort between the photographer and the model as they were working through the session. You usually know when the shot is working. You can feel it, even though you'd be hard-pressed to describe how you arrived at it. Try to explain to a novice that, instead of trying to take a pose that she thinks is elegant or fashion-like, she should think of her body in terms of fluid movements, like those of a dancer.

This series is a good example of how a model and photographer can interact successfully. Trina needed some new shots for her book and Barry also wanted some newer images, since it's important for photographers to keep their portfolios up to date in terms of models' hairstyles, makeup, and clothing. Hair-and-makeup artist Ken-Ichi gave Trina three different looks for a little variety. These shots were made with one of Barry's favorite lighting setups: four strobe heads firing through umbrellas basically surrounding the camera. Be sure the umbrellas are the same make or at least the same translucency. Trina stood against the white studio wall for a ring-of-light look. The highlights in the eyes look natural or as if reflected from a bank of windows.

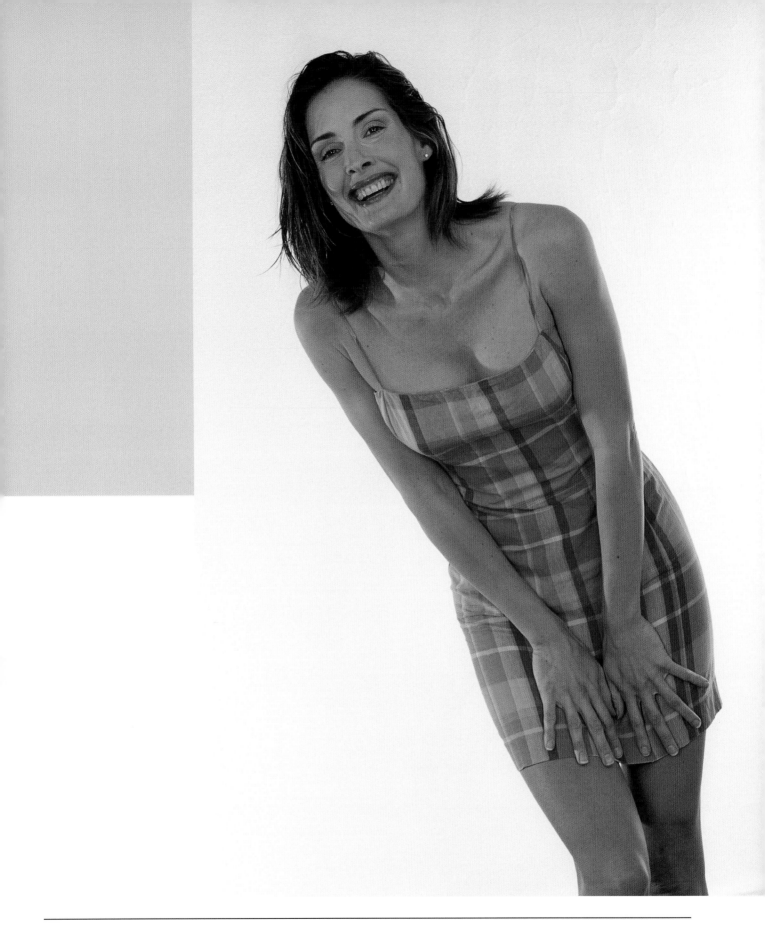

Here the same lighting was used as in the previous series, with the addition of a 500-watt-second background light. The four heads as the main light are at 100 watt-seconds each, for a total of 400 watt-seconds. The background has 25 percent more exposure. Be careful using more than 50 percent more exposure on the background when using white because it will start flaring, which can affect the saturation. For a little variety, Barry decided to leave the light shadows on the left side of the face caused by the background lights.

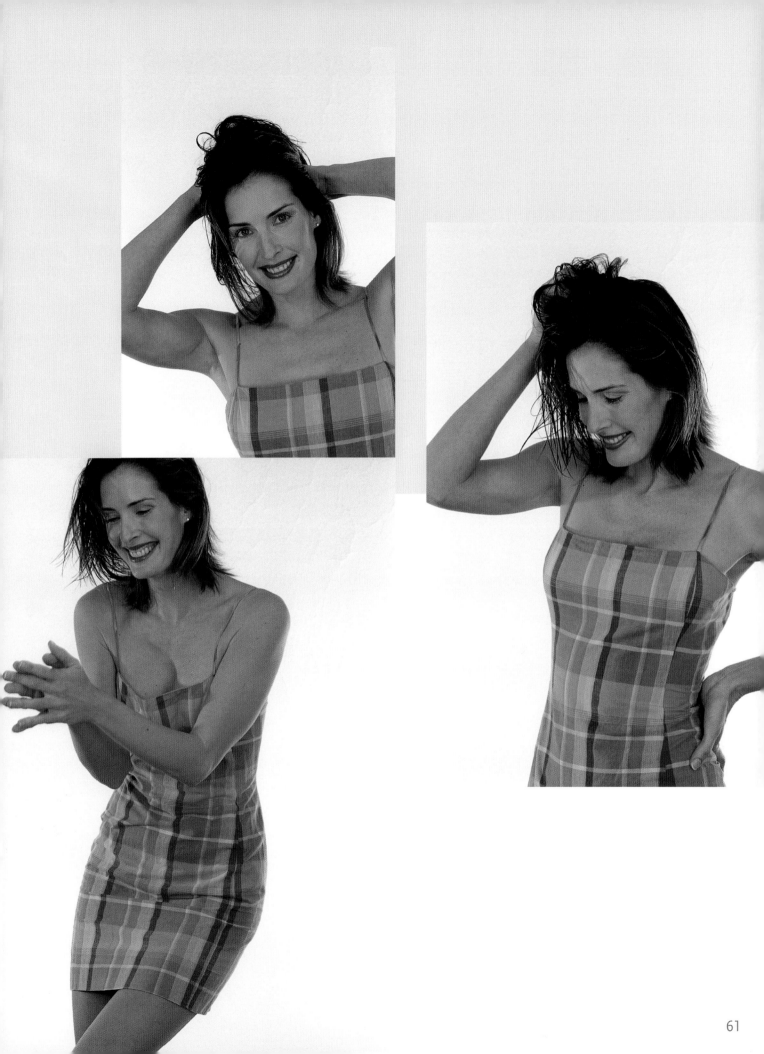

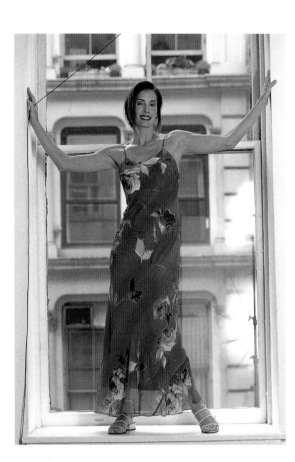

For this shooting with Trina, Barry rented the Bob Rock studio on lower Broadway in Manhattan. He put Trina in the huge loft window, handed her the phone, and just said go.

This is a perfect example of the advantages of using a professional model: you can just let them move once you set up the situation. Don't get caught in the "overdirecting" mode; create the scene and let your talent improvise, as most pros prefer to do.

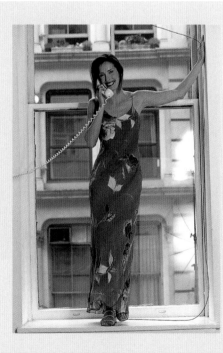

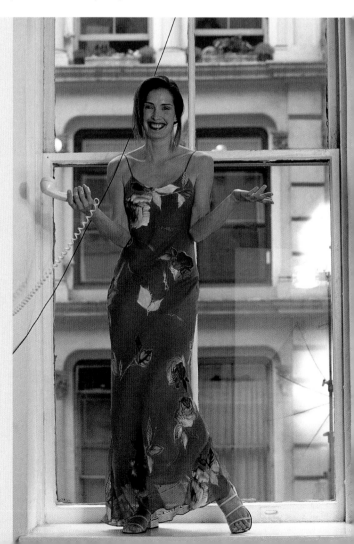

The lighting for this series consisted of two umbrellas, one above the other, and a 250-watt quartz light bounced off the ceiling. Barry intentionally left the reflections in the window. The exposure was f/4.5 for the strobes (the main light), f/2.8 for the quartz, and the available window light controlled by the shutter was 1/30 sec. The quartz was added for warmth in the color but kept at one stop less than the strobe for the color balance mix.

Whenever possible, think "out of the box." Do something unusual, have some fun—that is what testing or doing portfolio shots is all about. When lunch arrived, Barry told Trina to stay put. He moved the worktable Ken had been using over to the window, put the lunch on it, and had Ken (on the left) and Bob act blasé. Trina immediately picked up on what was happening and played her part beautifully.

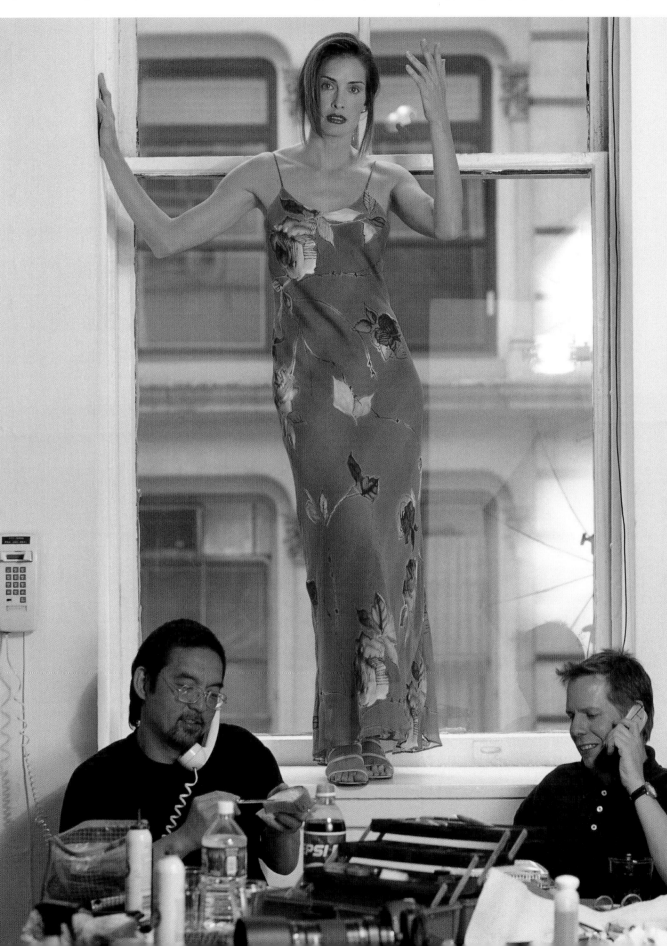

On Location

One of the most strenuous aspects of working on location is that you have to create a large variety of images in a given amount of time. In fact, you are often shooting a number of setups in one day. You may have more than one model on the shoot, which means someone is always ready to be photographed. One girl may be with the stylist while another is working with you and a third may be waiting in the wings. This type of shooting is among the best of any professional assignment, but it's not without problems. Most photographers would agree that you work much harder on location than on a studio shot because you have to deliver something from the shoot every day and there's rarely an opportunity for retakes. The combination of a new visual environment and the pressure of producing results keeps your adrenaline pumping for the 12- to 14-hour days.

Because a break is necessary during the hours of the harshest noon light, most of the shooting tends to occur between seven and ten in the morning and again around three in the afternoon until sunset. The quality of the light at these times of the day is so much more complimentary to beauty and fashion work.

Working on location frequently entails figuring out ways to deal with a variety of issues. Having contacts throughout the world to bounce questions off of regarding shooting conditions, transportation, airport X-ray problems, and the myriad details of a production is an enormous time saver.

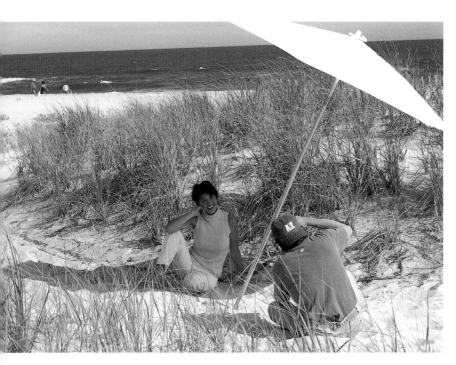

The first time Michael met Christina Beneton he fell in love with her fresh young look as well as her charming personality. When his stock agency asked him to shoot healthy, natural-looking women, Christina was the first person who came to mind. When they arrived at the beach the strong wind was wreaking havoc with Christina's hair but Michael discovered that there was barely a breath of wind if they sat on the sand dune. He tried some different camera angles and lenses to find an interesting background. Sometimes being confined to a very small shooting area unleashes more creativity because you have to hunt out the good shots. Challenging situations may lead you in a whole new direction that will produce results better than a careful plan. Remember simply to go with the flow. Because of all the bounce light reflecting off the sand, lighting was as simple as sticking a white umbrella in the sand to shield the model from the direct sunlight.

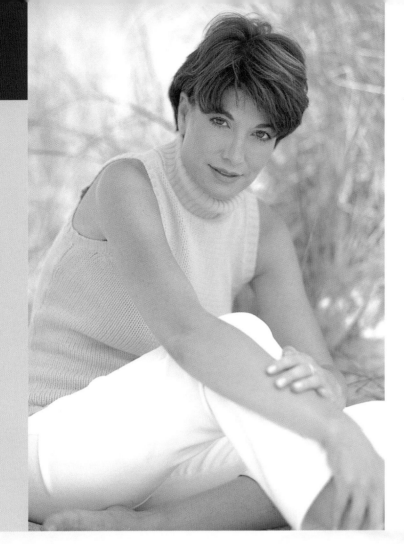

These two shots were made with an 85mm lens on E100S. For the image shown below, Michael switched to a 50mm lens with an opening of 1.4 to achieve shallow depth of field.

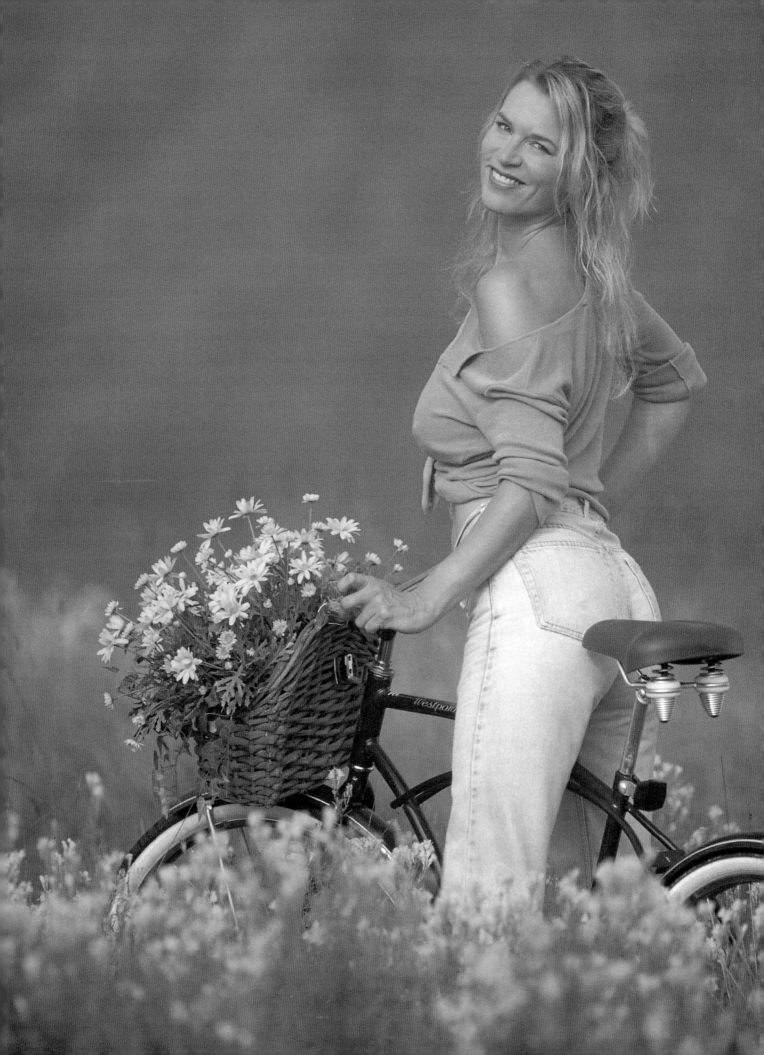

Michael had planned to photograph model Natalie Biers outdoors on a generic prop bicycle in a field of flowers with a wicker basket of silk flowers wired to the handlebars, but for days the weather continued to be a mixed bag of rain and sun and fog. Despite the fog they decided to begin shooting anyway. As the fog slowly burned off Michael changed position and instead of shooting with back light he shot with the sun at his back, heavily diffused by the slowly diminishing fog. A gold reflector slightly behind Natalie gave a little edge light but because of the varying density of the fog it didn't do much. These shots, taken on E100S film with a 300mm lens mounted on a tripod, show how the fog and the use of a long lens changed the lighting and the overall look. Some of the photos from this session look as if the model was placed in front of a light gray painted background.

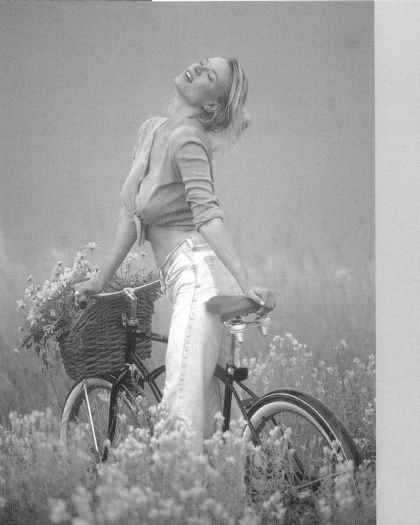

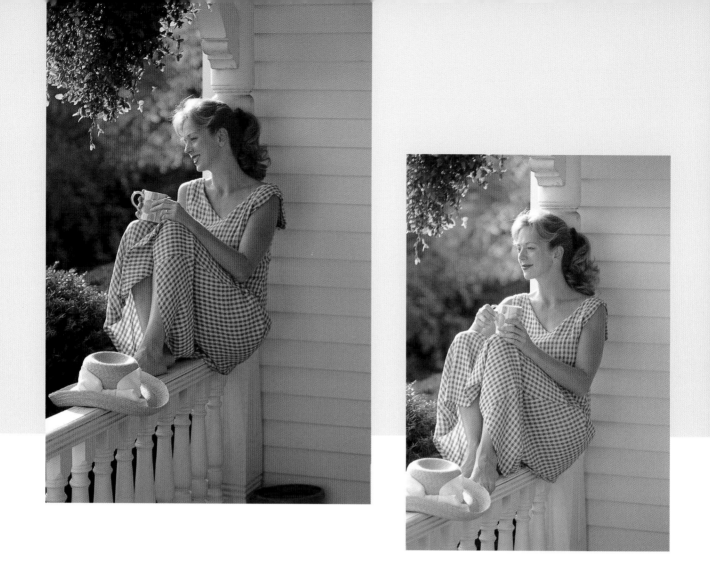

Barry discovered Lyndi stuffing composites into envelopes in the post office. He introduced himself and asked her if she was a model. As it happened, she knew who he was since she had worked with his daughter Shannon, who modeled for ten years. Lyndi was renting a lovely old Victorian house that they used as a location. Barry often tended to shoot toward the more saturated side as in the photo ABOVE LEFT, but the image ABOVE RIGHT is a more acceptable exposure for general stock sales. The photo BELOW with the sun slashing across the face would probably not work for stock, but Lyndi and Barry both loved it anyway.

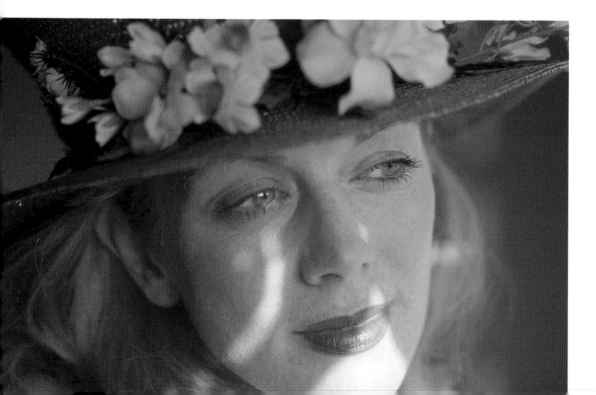

Backlight from the windows lends a very soft effect to this image.

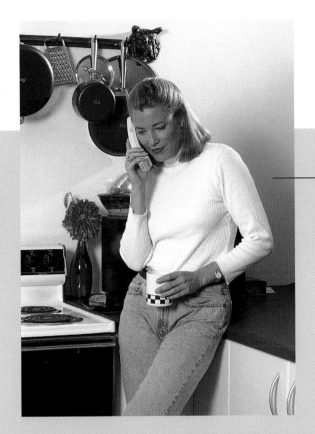

Betsy, whom Barry's daughter met when they were both getting started as models in Milan, is a perfect example of the consummate model—or ex-model, since she is now a mom with two children. Here she played the part of a sophisticated young woman enjoying loft living. Barry used strobes and HMI for the side light.

Daylight alone, through an east window, lights an early-morning image of blissful relaxation.

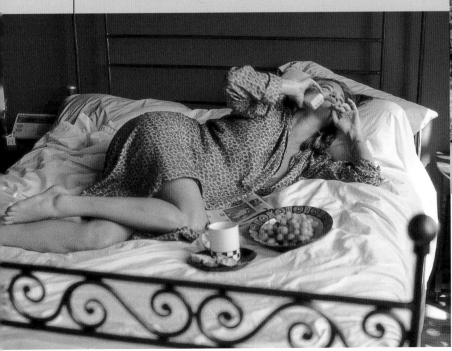

Barry shot this on Polapan and copied it on E100S Ektachrome.

The Mature Model

Agencies tend to place older models in the commercial category rather than fashion, runway, or editorial. These are the people you see in all those mailers for credit cards, mortgages, insurance, and the like. For this type of portfolio you have to shoot very straight stuff, no cross-processing, no crazy hair, just good clean shots in various situations. Nevertheless, older does not mean less attractive, and a talented model of any age can adapt to various situations with personality and flair.

After a long and successful career as a banker, Helen decided to give modeling a try. Her agency sent her to Barry, who agreed to help her put together a commercial portfolio. Helen was a lot of fun to work with and he subsequently used her for several jobs. She jumped right in to various situations that made good stock shots: executive, bus driver, affluent consumer, exercise fan.

Body Talk

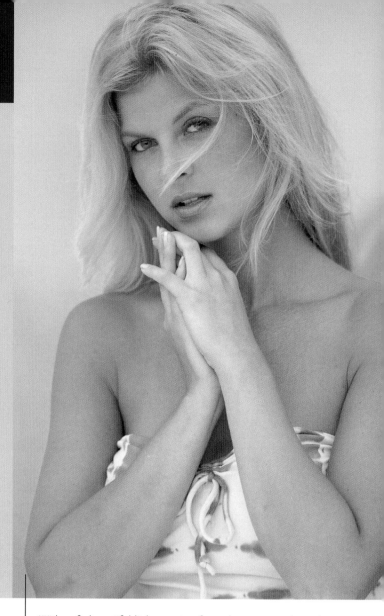

There are many things to consider in a bathing suit shoot, especially if the model is not moving. How does the collar bone area look, especially if she is in a twisted position? If she is leaning on her elbows, does it create a heavy, muscular look in the upper arm? Does she have "saddlebags" at the outside of her thighs? Does the suit pull in the stomach? Each model is different but after the first few rolls you can begin to see how to bring out the best look. Although these considerations apply particularly to swimsuit work, they are also relevant to models wearing other types of revealing clothes.

Too often clients and casting people look so hard for perfection that many girls who would be wonderful for a particular shoot are turned down. Most models know their own shortcomings and will point them out to you. Some problems are not nearly as bad as they make them sound, but if you have dozens of people tell you your thighs are a little on the heavy side you become more aware of them than necessary.

The line of the body is especially important in swimsuit photographs, and sometimes the photographer can make suggestions to help exaggerate the hip line or make the model's legs look longer. In some instances, you may want the body to appear simply as a sensual form or a design element in a shot, so any awkwardness of pose can throw off the lines.

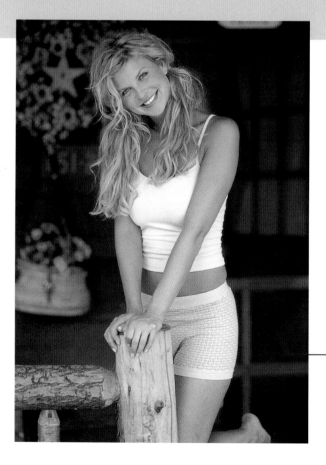

With soft, beautiful light coming from the western sky and just a few minutes to grab some shots, sexy lingerie and swimsuit model Carrie Flaska put on a baby blue shirt while Michael grabbed the matching blue fabric she had brought with her. An assistant held up the fabric and Michael placed a white show card waist high beneath her to bounce light up to her face.

Carrie tried out lots of different looks for Michael, who frequently asks models to change clothes, props, and backgrounds to increase the sales potential of stock shots. For this photo, taken on the porch of the guesthouse at Michael's Pennsylvania studio, he used a gold-and-white reflector.

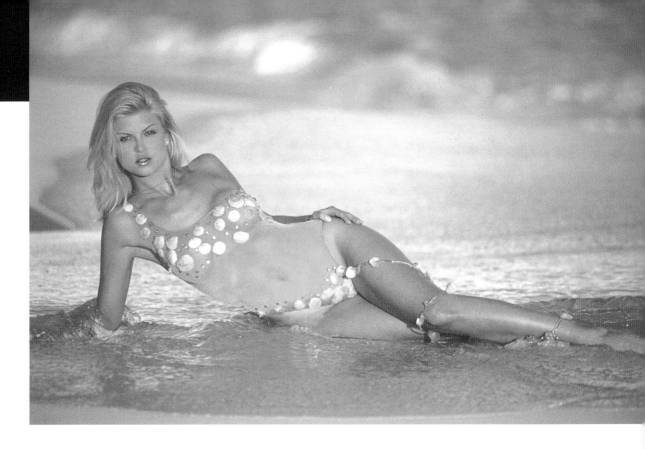

During an assignment shoot for the Sheraton Grand Hotel in the Bahamas, Michael and Carrie started the day before sunrise to catch the first rays of light over the horizon. Positioning her at the water's edge, he first chose a slightly high angle (ABOVE) to block out the vacationers in the background and give the feeling that this was a secluded, private beach. They tried several poses but this elongated one best showed off her beautiful legs and body. Then, before the sun got too high, Carrie changed into another swimsuit and moved higher up the beach. This time there was no one in the background so Michael chose a lower angle to show the sea and sky.

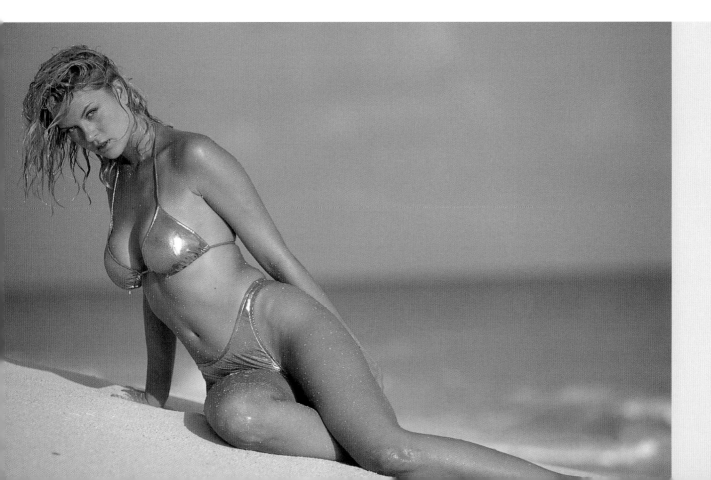

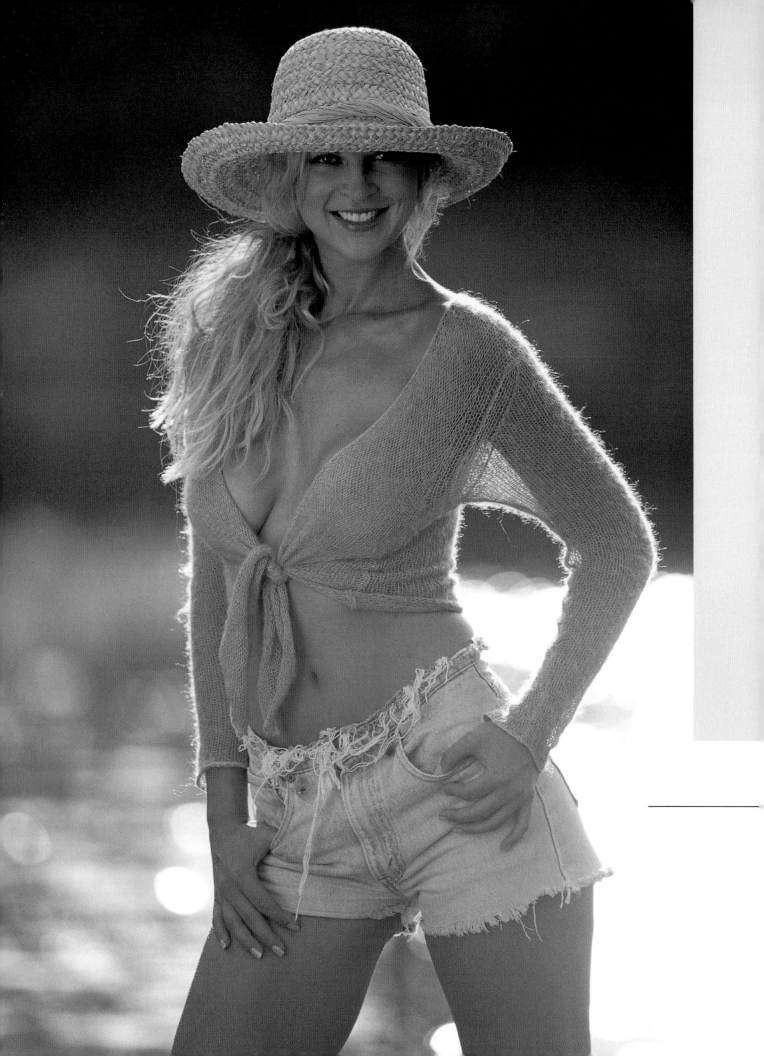

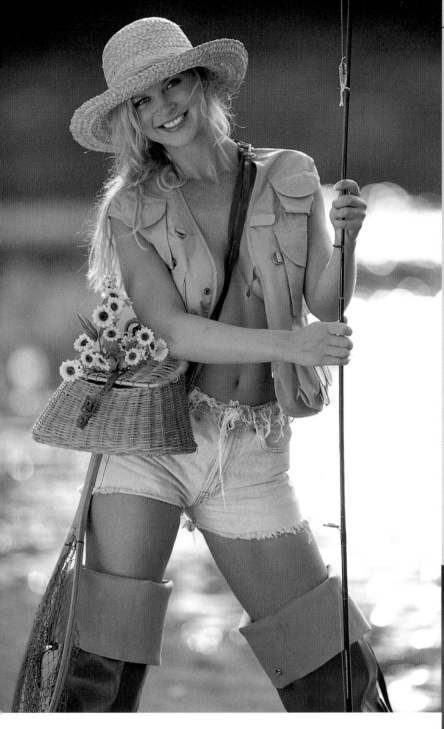

The late afternoon sun sparkling on the water provided a wonderful backdrop for some fishing shots of Carrie taken near the pond at Michael's studio. Carrie's boyfriend, Brian, acted as assistant and held the reflector. Note the warming effect on the skin of the gold reflector used in this shot, taken with a 300mm 2.8 lens mounted on a tripod, set wide open for the least depth of field.

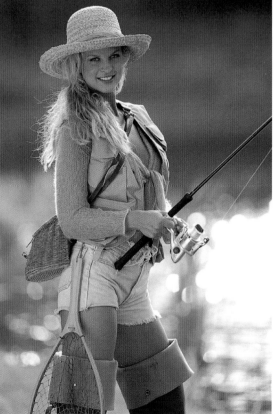

Here the white reflector provides a softer white light but not as much punch. Keep in mind that a reflector will enhance the color temperature of your light source, so by using a gold reflector late in the day you may be making the already warm light too warm. Also remember when shooting photos for reproduction you must choose your reflective surface wisely.

Michael purchased this seashell from a native islander strolling along the beach. He asked model Josette to hold the shell up to her ear. The direct overhead sunlight cast very hard shadows over her face, so the assistant held a white umbrella about a foot above her head. Because of the brisk wind, Michael decided to shoot at a slow shutter speed to show a little movement in the hair. The camera was mounted on a tripod with a 135mm lens and the exposure was 1/8 sec at f/16 on Fuji Sensia ll film.

For a pretty body shot during a photo shoot in the Bahamas, Josette changed into a one-piece yellow swimsuit and lay down on a white towel. Just before Michael set up the white umbrella to diffuse the harsh noonday sun, a huge cloud moved in. He used an 85mm lens and Fuji Sensia ll film, with no light manipulation at all—thanks to that cloud.

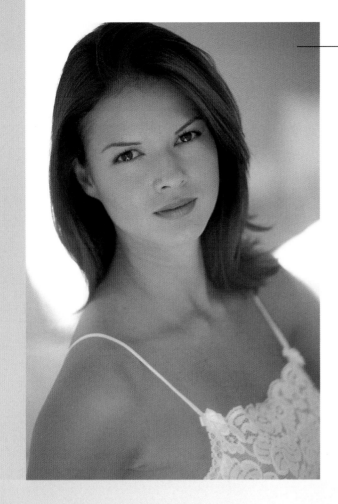

During lunch break Michael noticed a soft, beautiful light reflected off Josette's camisole top and he placed a silver show card under her face to add a little more light and sparkle to her eyes. He used an 85mm lens at f/1.4 on Kodak E100S film.

When they returned to the beach that afternoon, clouds had moved in after a rainstorm left a light fog in the air. Combined with the overcast sky, the mist provided a soft, even light that needed no manipulation. Michael brought in a white Adirondack chair and had Josette put on a pair of white jeans. Josette herself suggested leaving her top off and covering herself with her arms, resulting in a very sexy photograph.

Lingerie

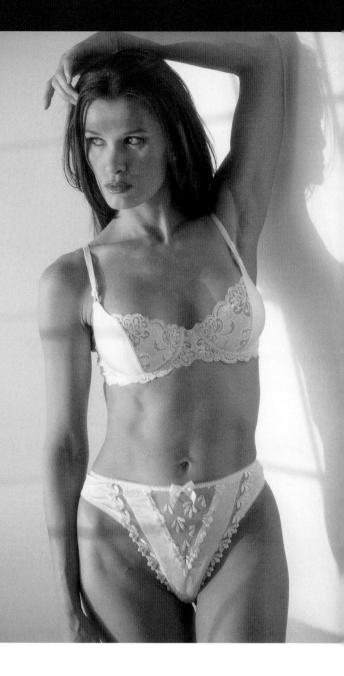

Lingerie photography is similar to other types of fashion work. The client may simply want you to suggest a style or look, or they may want to see every stitch of their handi-work but no wrinkles. The photographer must strike a subtle balance between conveying the mood the client wants and keeping the shot from becoming too suggestive. Some manu-facturers want to appeal to a very conservative audience, while others want to capture the young independent woman who is interested in a more sensuous look. The control of the end result usually rests with the photographer and depends on how he relates to the model and how the model relates to the photographer and the situation.

Once the set, lighting, and mood have been agreed upon by the interested parties, it is up to the photographer to get the right reaction from the subject. This is among the more delicate of photographer–model relationships, and it is very important for the photographer to have a say in the casting of this type of shot.

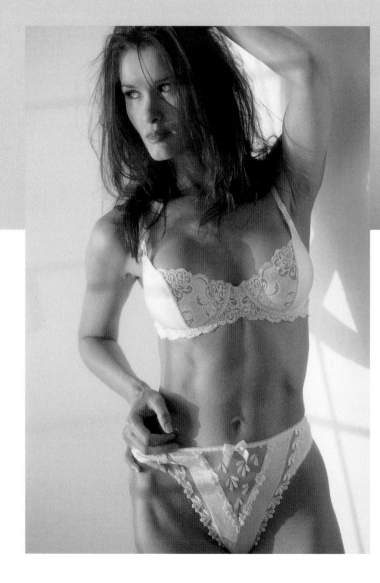

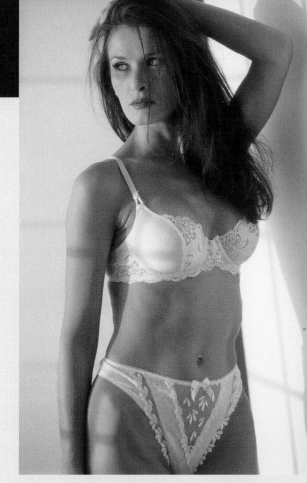

For this series of Lana (see also pages 18–21), Michael decided to create his own sunset using a technique he often employs to suggest artificial sunshine on rainy or cloudy days. Outside he placed a single bare strobe head with a full CTO gel, aimed at the window about 15 feet from the studio. A Polaroid revealed that the square window grills were throwing very hard shadows on Lana and the background, but Michael liked the effect of the grills and just needed to soften the shadows a little. He placed a sheer white curtain over the window, took another Polaroid, and was happy to see that it worked perfectly. It was sheer enough to soften the shadows without removing them completely.

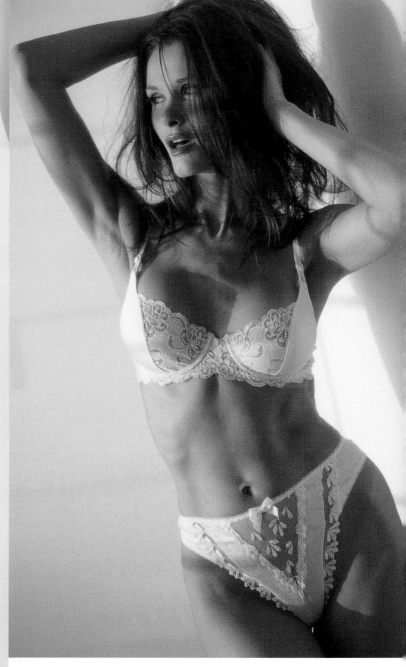

Promotional Pieces and Composite Cards

Creative directories are books, like the yellow pages, that showcase photographers, makeup artists, assistants, processing labs, prop shops, set builders, equipment rentals, modeling agencies, and so on. These books are used by advertising agencies, art directors, and graphic design houses to hire photographers for assignments or to purchase stock photography. They are also used by photographers to locate talent and support services. Many photographers purchase a page or a double-page spread in one of these books every year in hopes of reaching some magazine or art director for an assignment. For the price of being in these books you usually receive 2500 to 3000 reprints of your ad that you can use as a promotional piece to mail out or as a photo business card to show potential models examples of your work.

Composite cards are the model's business card and are extremely important for landing assignments. In exchange for the model's time and a signed model release for use of the images, many photographers will absorb the costs of film, processing, wardrobe, assistants, and makeup artist. The model receives many pictures from the shoot to use in model agency catalogs, web site pages, and composites to use for promotion, and the photographer obtains saleable pictures. This arrangement can be beneficial to both the beginner and the professional model as well as to the photographer.

Lisa spent three days with Michael at his Pennsylvania studio to try some new ideas for his stock files. They strung a hammock between two trees, where shade blocked the direct sun from hitting Lisa. He shot with an 85mm lens and placed the focus on different areas in a series of images to increase sales potential.

When Michael's friend Annette Linton requested new shots for her promo card, he invited her for a weekend at the studio, where the more casual pace allowed more time to plan shots and wait for good light. To achieve an image that looked as though he happened upon her while she was having morning coffee on the patio, Michael seated Annette on a rustic twig chair beneath the covered front porch of the studio and propped some sunflowers from the garden for some background interest and color. He placed a white 4x6-foot reflector card out on the lawn, bouncing direct sun back to light up Annette's face.

Michael noticed beautiful light coming in through the French doors, so he grabbed a white sheer curtain and hung it over the doors. He placed a satin silver show card slightly behind Annette to add a little highlight to the side of her hair, ear, and face. She sat on the floor and he stood on a ladder until he found a suitable composition, siting her face between the shafts of light hitting the maple floors from the two skylights. These light patterns added more interest than a plain background. He shot with an 85mm lens and E100S film.

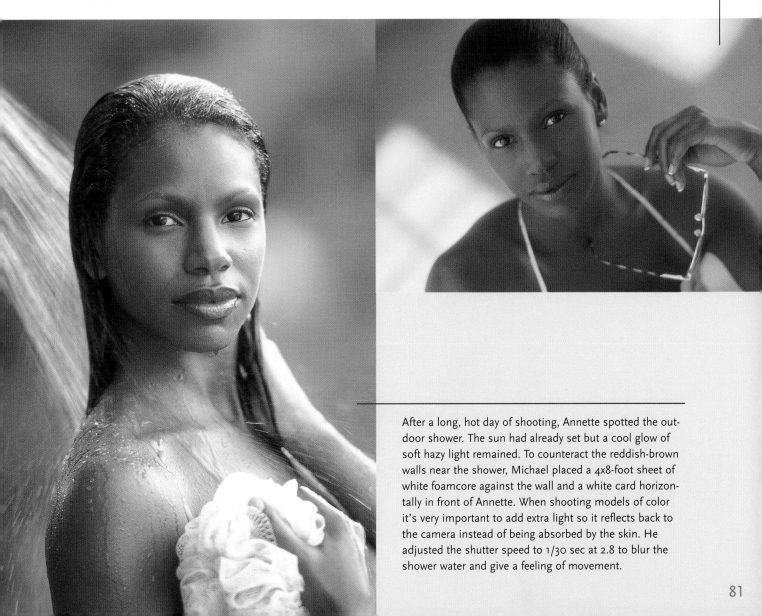

After a long, hot day of shooting, Annette spotted the outdoor shower. The sun had already set but a cool glow of soft hazy light remained. To counteract the reddish-brown walls near the shower, Michael placed a 4x8-foot sheet of white foamcore against the wall and a white card horizontally in front of Annette. When shooting models of color it's very important to add extra light so it reflects back to the camera instead of being absorbed by the skin. He adjusted the shutter speed to 1/30 sec at 2.8 to blur the shower water and give a feeling of movement.

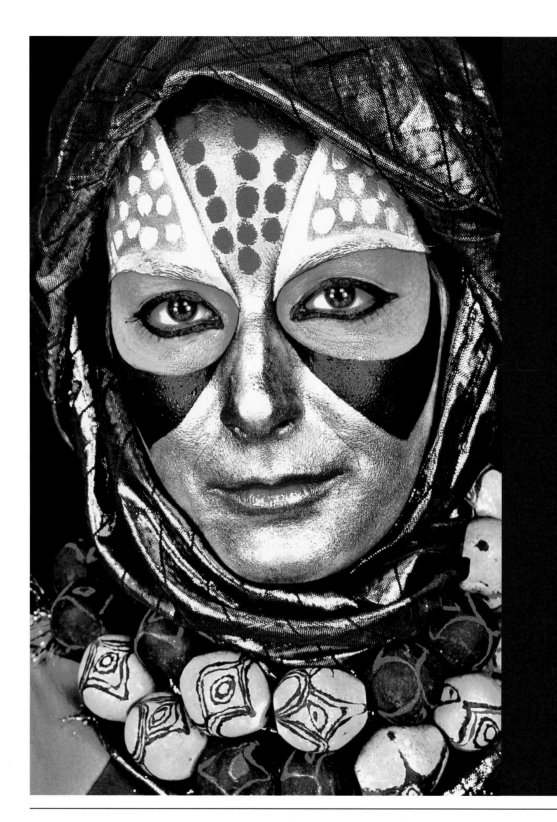

Digital Photography

Barry recently jumped headfirst into digital photography. It began when he acquired a Mac G4 with all the bells and whistles. After six months of a little success and a lot of frustration, he took a week-long course in Photoshop One at the Santa Fe Workshop, taught by Josh Withers, who was assisted by Josh Samuelsen and Tom Gaukel.

Dorian Roamer of Kodak Professional in New York provided a Kodak DCS Pro Back for the Hasselblad through Fotocare. Jeff Hirsch's great staff made sure Barry knew how it worked, and Bob Rock produced the shoot.

Mike Newler of Canon has been responsible for helping make the company photographer-friendly. He created the "Explorers of Light" program, a group of sixty-five professional photographers worldwide. Through this program Barry was able to obtain a Canon D30 shortly after they became available. In RAW mode, the D30 records the image in 12-bit with no compression. Barry was quite impressed with the camera's metering system, which is capable of perfectly balancing the background with the precise amount of flash needed for the subject.

Barry used the Kodak DCS Pro Back on the Hassleblad and downloaded immediately into a G4 Powerbook. This back uses two IBM 1GB microdrives, so your assistant can be download-ing while you continue to shoot on the other, or both drives can be left in the back, which will switch over when the first one is full. This back fits on an ordinary Hasselblad or Mamiya 6x7. The final image is 48 megabytes. One nice feature is the ability to shoot fast: the back will store the information of six quick shots and then pause to read it or transfer it to the card, rather than pause between each shot.

For the amateur camera Barry used the Canon Power Shot S110 Digital Elph with a capture file of 2.1MB. He also shot a roll of Kodak E100S 120 film on the same Hasselblad, simply adding a traditional 120 back. He used Connecticut Photographics for all E6 processing; they also function as a digital lab. For the 35mm outputs they used Kodak Elite Ektachrome and a Polaroid Pro Pallet Film Recorder. Nancy Scans provided the transparency output.

Rapid technological advances in digital equipment, coupled with the seemingly magical possibilities available through Photoshop, provide unlimited opportunity for creative photography.

Digital Versus Film

Barry arrived at the Photoshop course in Santa Fe believing that film was here to stay, but now after shooting with the Kodak DCS Pro Back for the Hasselblad he is considering turning his darkroom into a wine cellar! He now shoots everything on film and digital and envisions moving toward digital exclusively when a 35mm format can capture a larger file than the current models.

Learning about the technical aspects of digital equipment can be overwhelming, so Barry advises getting on friendly terms with a technician at a service bureau (a lab that handles digital imaging). You may also find it quite helpful to attend a workshop or take a course to increase your knowledge and your comfort with the equipment.

The photo of Alex above was made on film, while the one at left is digital, using a large and a small soft box for full beauty lighting. Barry enhanced the green and the red in Photoshop. (See page 26 for a description of the lighting setup.)

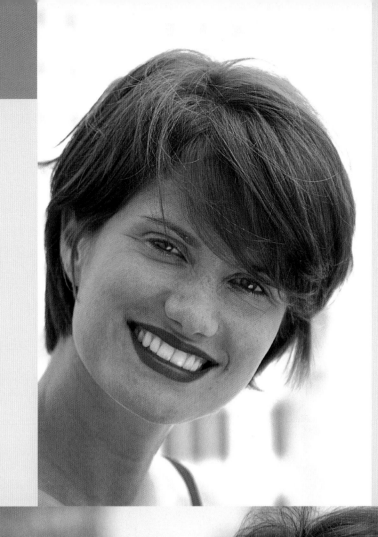

With Alex out on the balcony, Barry took this digital shot (LEFT) using a large white umbrella as a scrim and a dull silver reflector card for fill, then output to 35mm. The other shot, on film, is shown for comparison.

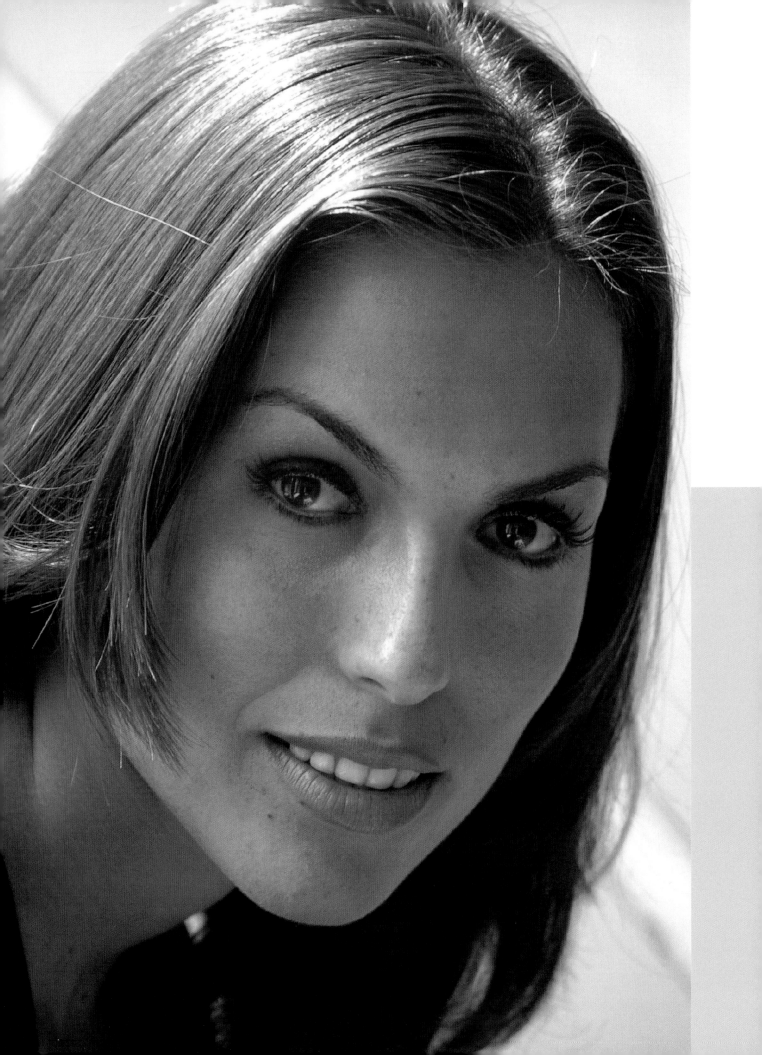

This basic lighting shot, with a white fill card placed lower right, was made with a 28–135mm zoom lens on the Canon 1V with Kodak E100S film.

Digital images made with the Canon 180mm macro lens in available light. A large white reflector on Tiffany's left and a silver reflector in front bounced the sun from a south-facing window into her face. The image at right was output to Kodak 35mm Elite film; the one opposite, made with the D30, was output to 4x5 by Nancy Scans.

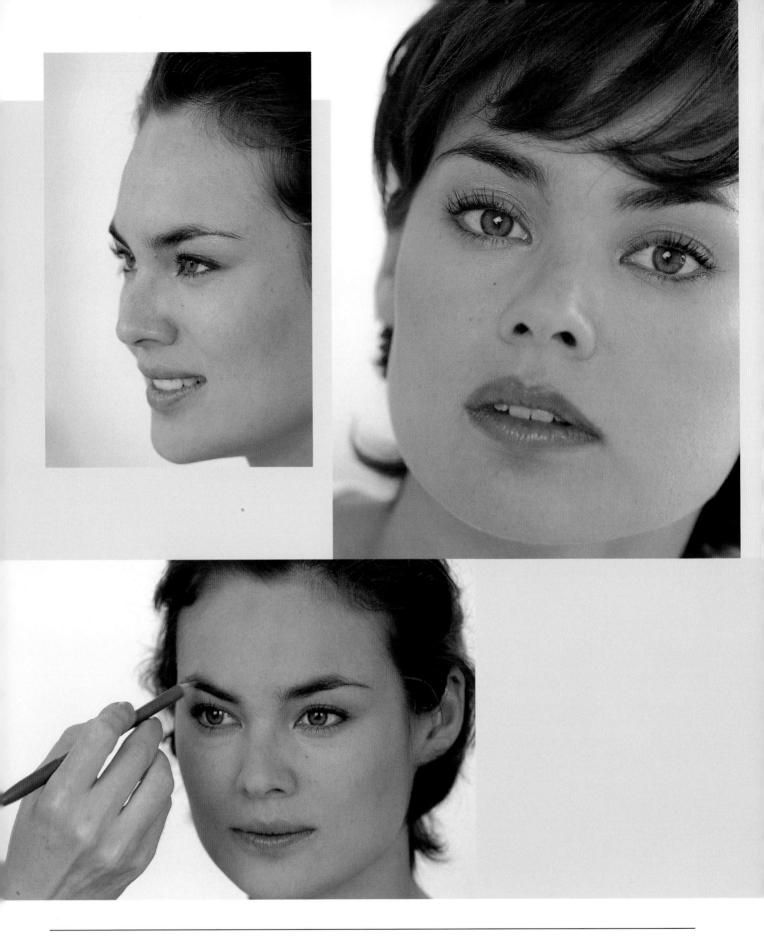

The photos on this page were all made on film with the Canon 180mm f/3.5 macro lens, for comparison to the digital images seen opposite. (See page 16 for a description of the lighting setup.)

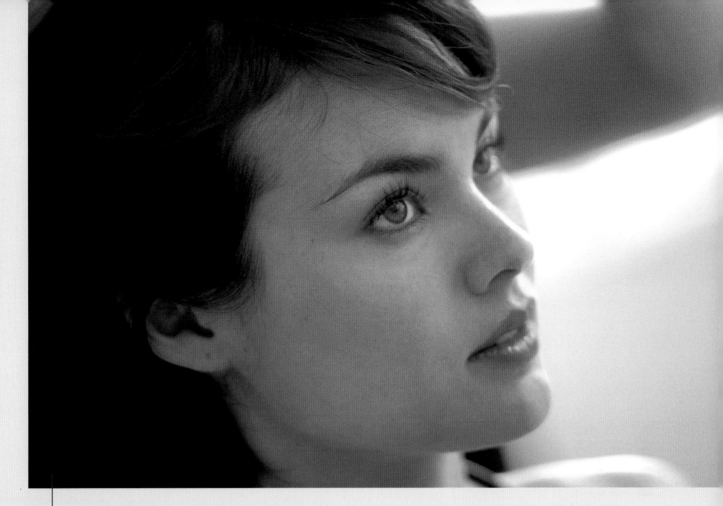

This photo of Nadia was made with the Canon D30 and a 28–135mm lens, output to a 35mm chrome. Lighting was a combination of available light, makeup mirror lights, and window backlight.

Taken under the same lighting conditions and again using the D30, this image was output to a 4x5 chrome.

Electronic Retouching

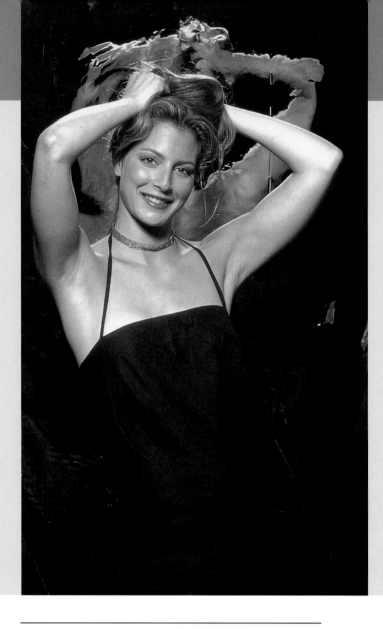

Thanks to today's technology, it's very easy for the photographer to remove freckles, moles, bags under the eyes, dust spots, scratches, and any number of other blemishes that threaten to ruin an otherwise terrific photo. The final results are the perfect Photoshopped person! Besides doing away with unwanted aspects, the software also allows you to change eye color, add texture to skin, and much more. Before you know it you've spent hours fiddling around, just playing with all the "tools" available, and you may not actually have accomplished much. Barry's advice is to get a good book on Photoshop (don't rely solely on the manual that comes with the software). With a digital camera, you can download directly into Photoshop, but if you're shooting on film you'll also need a good film scanner.

ABOVE: Compare this digital shot of Stephanie without any changes to image OPPOSITE, where Barry blew out the skin tone and increased the contrast, which took only about fifteen minutes working in Photoshop, using Levels, Hues and Saturation, Color Balance, and Brightness and Contrast.

Taken on film, this image of Stephanie has an entirely different quality than the digital shots. (See page 29 for a description of the lighting setup.)

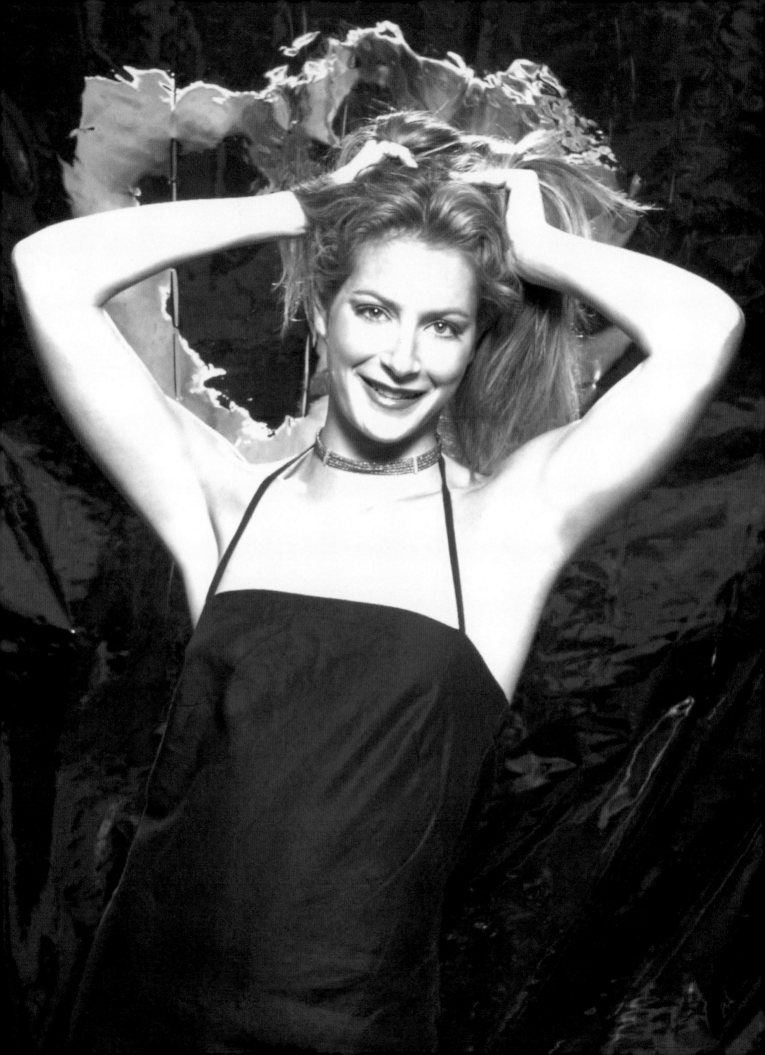

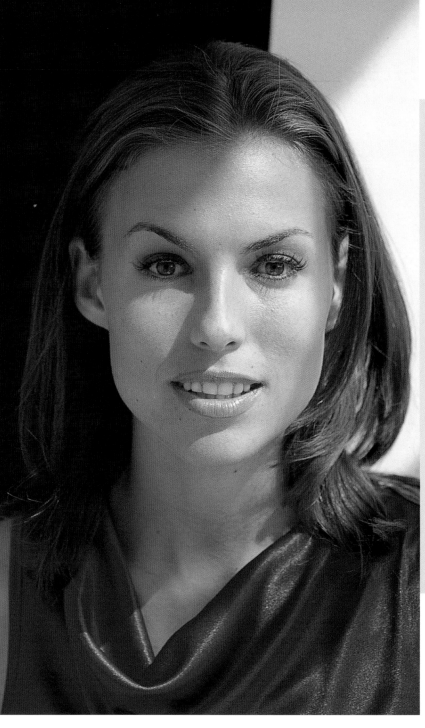

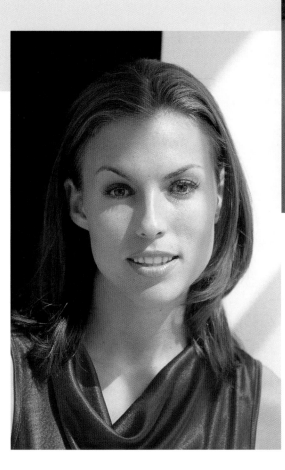

Shown for comparison with the digital images OPPOSITE, these two film shots were made with the lighting setup described on page 22.

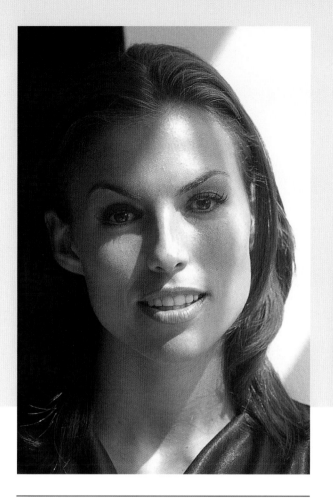

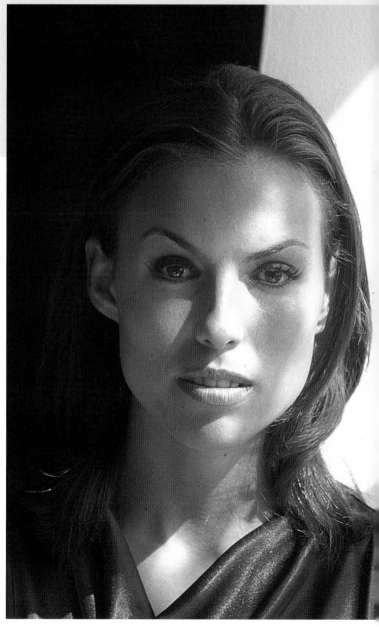

These two digital images, made with the D30 and various lenses, were made at the same time as the film images, but Barry ran these through Photoshop and did a little retouching, making subtle changes, adjusting the skin tone with the Levels tool, then playing with the color balance, saturation, and contrast.

These two film shots illustrate just how white the background and Trina's dress were before retouching was done. (See page 59 for a description of the lighting setup.)

Made at the same time as the film images, these digital shots were taken with the D30 and various lenses. Barry ran these through Photoshop and did a little retouching, adjusting the color balance and the saturation.

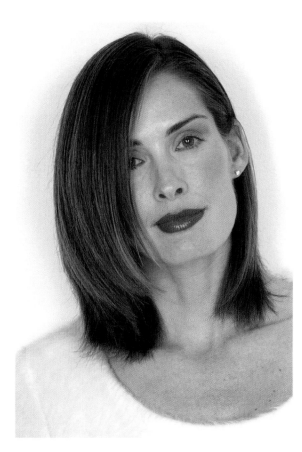

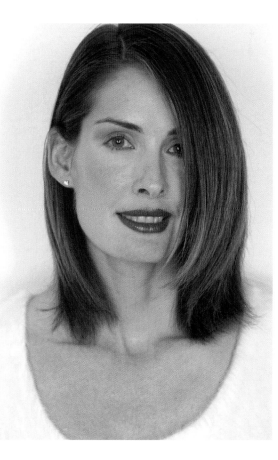

Digital Manipulation

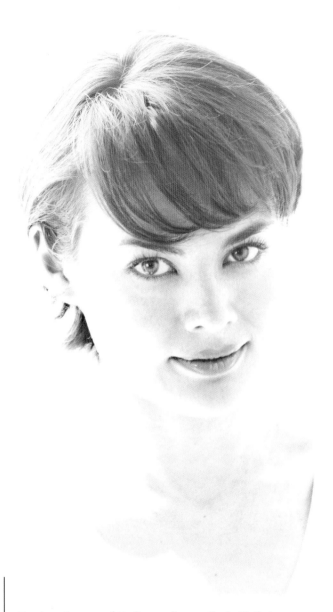

The terms "retouching" and "manipulation" are often used interchangeably, but technically retouching generally means cleaning up an image (removing blemishes or the like), while manipulation can refer to more drastic changes such as completely altering the color, changing a background, or adding or subtracting an object.

Barry gave art director Kevin McGuire a CD containing three digital shots without any changes made to them. He asked Kevin to do something with each one that would be acceptable to him for use in an ad. On these pages and on the following two spreads, you can compare Kevin's manipulations to the straight shots made with film and witness the dramatic changes he made without deviating from the concept of an acceptable beauty image. He worked in CYMK, which means these are press-ready.

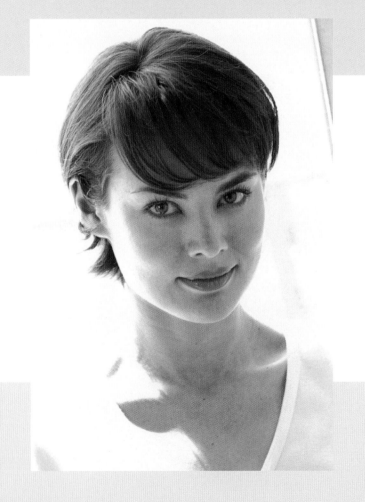

For these images of Nadia, art director Kevin McGuire first masked out the whites of the eyes, then he removed some of the magenta and cyan in the whites, using the Selective Color tool. To punch up the flesh tones and the contrast, he duplicated the main image layer and overlayed it at 100%. To give the hair a red cast, he made a new layer and filled it with these color percentages: cyan, 24%; magenta, 58%; yellow, 6%; and black, 2%. He masked off the face and made the layer overlay at 75%.

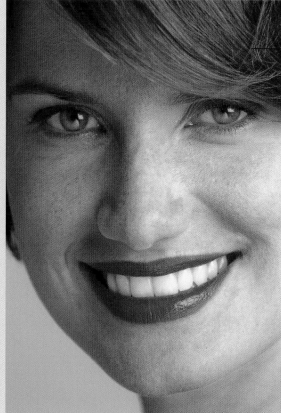

In these images of Alex, Kevin first adjusted the flesh tones and saturated the overall color. He made a color adjustment layer for the lips and enriched their color. He then isolated the eyes, adjusted the contrast of the pupils, and pumped up the highlights to make the pupils appear shinier.

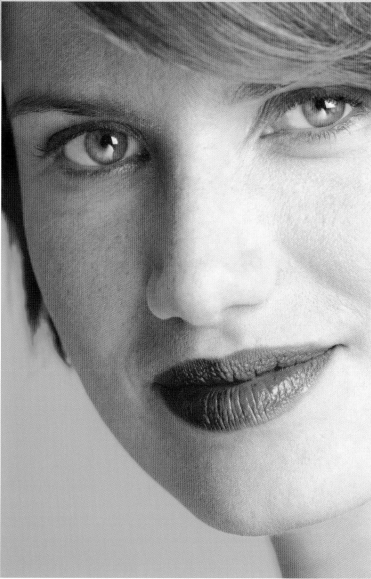

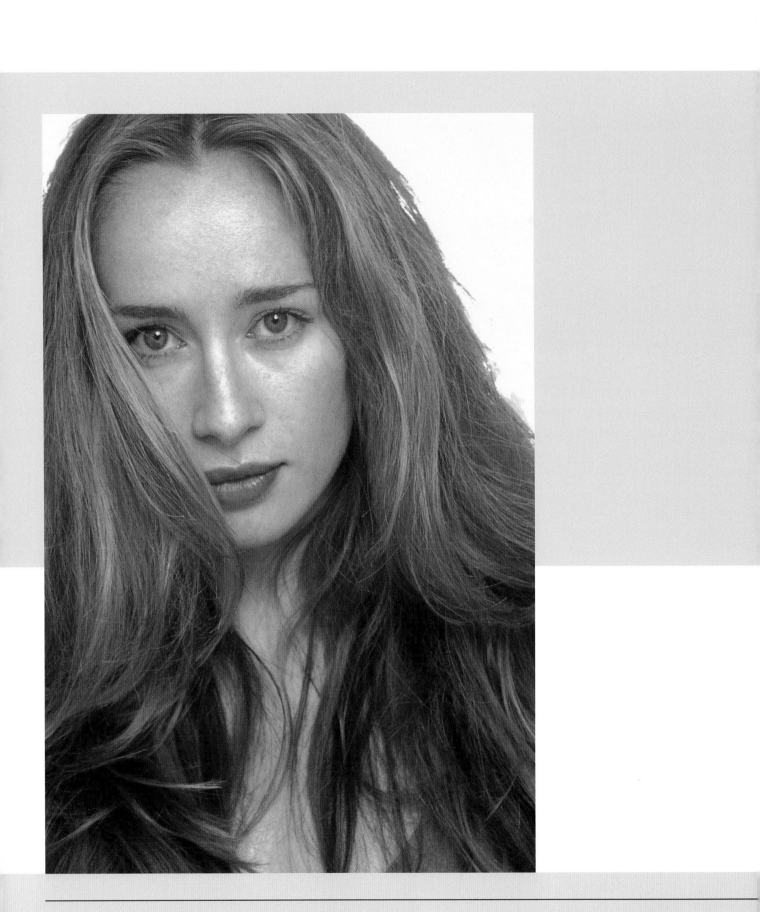

For Diana, Kevin masked the hair, eyes, flesh tones, and background to isolate each element. He created a blue background by sampling the color of her pupils and filling a new layer with the blue. He colored a second layer a darker shade and used the wind filter and a motion blur to add depth and excitement. He enriched the hair color by using the first mask and pushing the slider bars in Levels far inward.

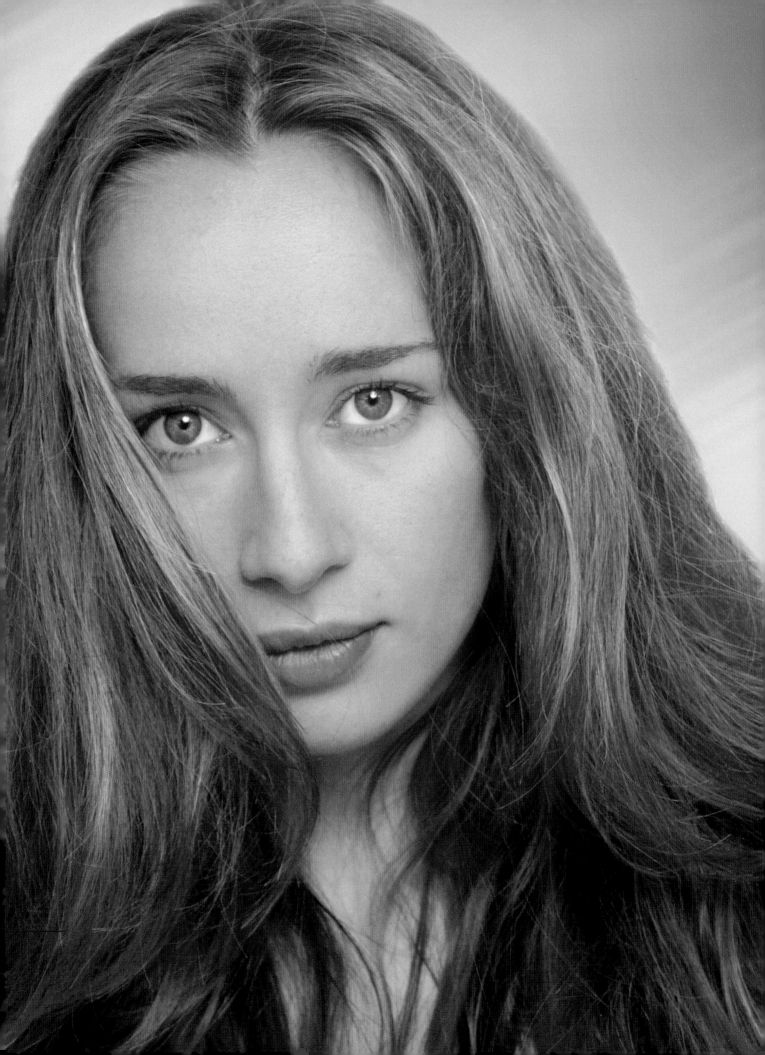

New Technology

hen Canon gave Barry the opportunity to try out their newest professional digital camera, the EOS-1D, he jumped at the chance. At the time of this writing, the EOS-1D is the most advanced 35mm-format digital camera. Capable of high-speed continuous shooting and exceptional image quality, it features various presets, including daylight, overcast, tungsten, and fluorescent, in addition to custom settings for color temperature matching. With its CCD chip, the EOS-1D can shoot up to eight frames per second, with a file size of 12MB. Since there's no delay for capture time, this is a great camera for photographers shooting people in motion: there's no risk of missing something while waiting for the camera to capture the image onto the flash card. Photos can be recorded as 12-bit RAW files or in a JPEG format.

The even newer EOS-D60, with a CMOS chip, does three frames per second but has an 18MB file.

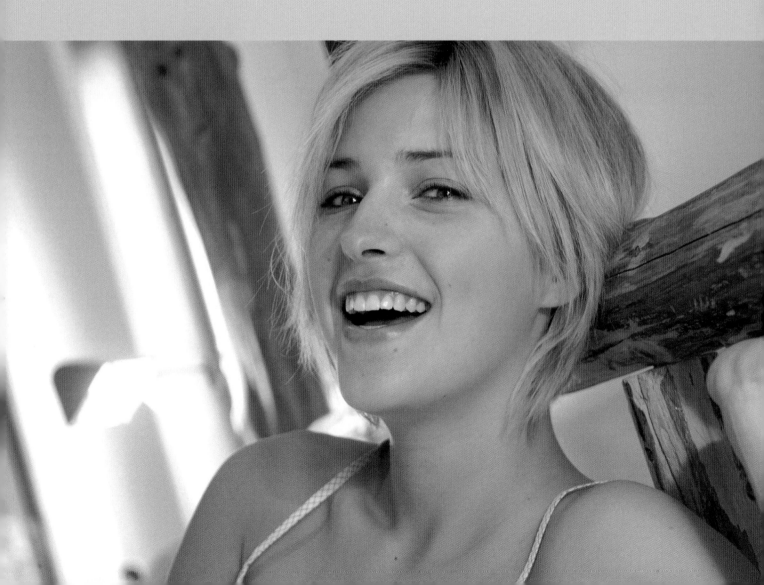

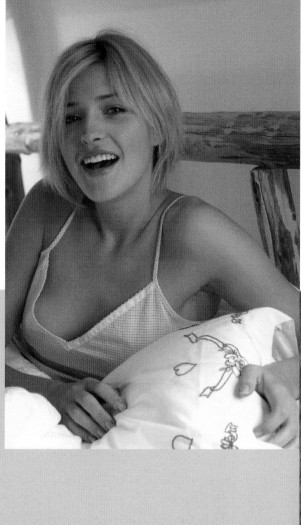

The Canon EOS-1D 4-megapixel camera captures a very rich tonal range, as seen in these 4x5s of Kelley. All three of these pictures were output from digital images made with the EOS-1D and a Canon 180mm f/3.5 macro lens. The ones shown LEFT and OPPOSITE were taken with available light from four large windows, supplemented by 300 watts of standard house lamps. In the photo BELOW, the lighting was diffused early-morning daylight from a south-facing window.

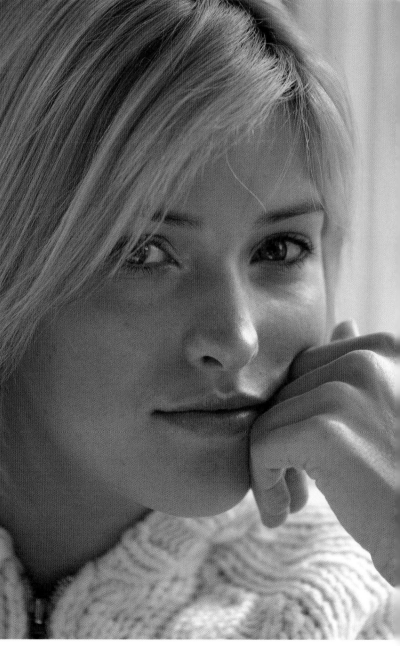

Dramatic Impact

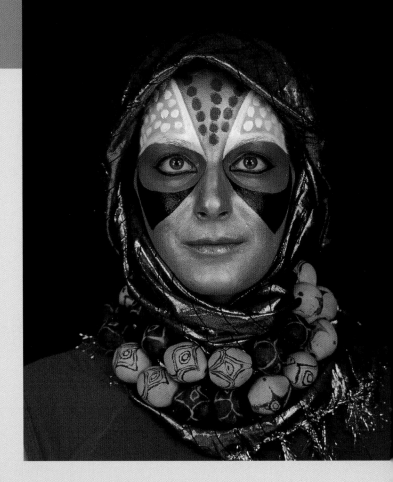

arry has been working with hair-and-makeup artist Ken-Ichi for over fifteen years. After finishing with the first series of models for this book, Ken said he was looking for some really special shots. He decided that Stephanie had the perfect look for the contemporary Kabuki image he wanted to create. Ken supplied the gorgeous necklace, which is several hundred years old.

The vivid colors and strong contrasts make for a truly dynamic photograph. And with Photoshop, of course, there's virtually no limit to what can be done with an image like this!

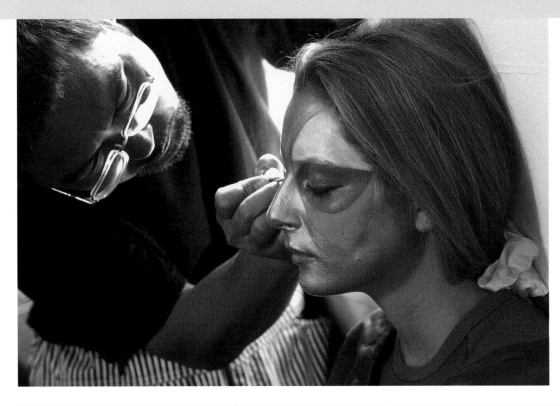

Barry teamed up with hair-and-makeup artist Ken-Ichi to do create some special digital shots using the 48MB Kodak back. Ken chose model Stephanie because he liked her facial structure for what he had in mind. After two and a half hours of makeup, Barry photographed her using three different cameras. The image ABOVE RIGHT was shot on Kodak E100S film for reference with the digital images. These shots were made with the 150mm lens on the Hasselblad and all the cameras were set at the same exposure of 1/30 at f/11.

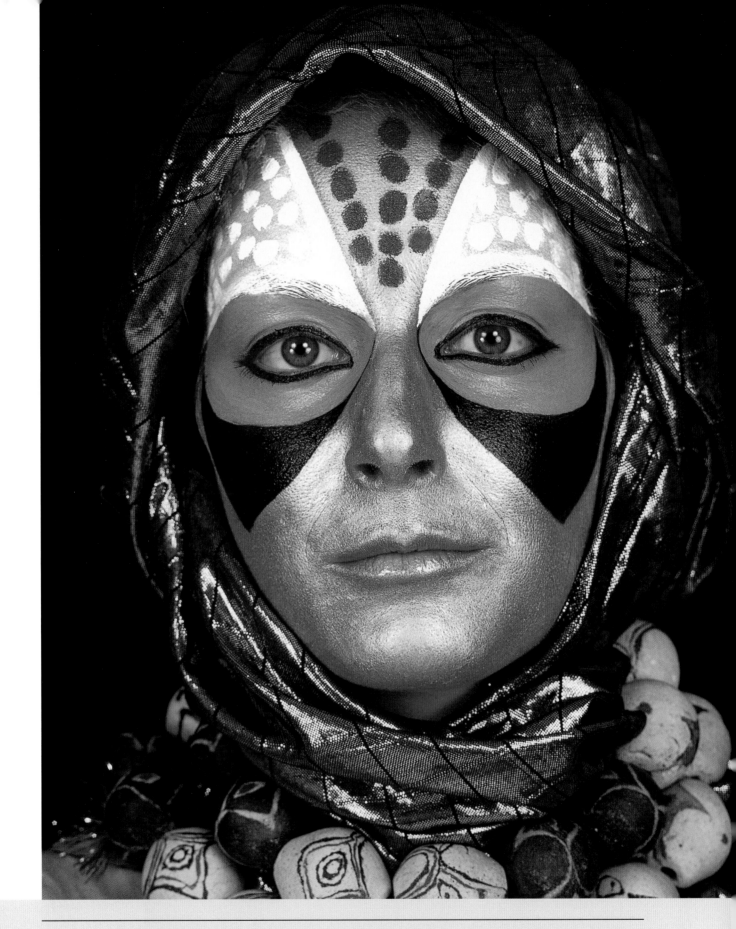

Barry increased the tonal value of the gold in Photoshop, but with his limited experience he pushed the contrast a little too much and lost some "information" in the highlight areas. This 4x5 output of the 48MB image was made by Nancy Scans using a Cymbolic Sciences Lightjet 2080.

Taken with the Canon D30 and an 85mm lens, this straight shot had no corrections made. The exposure was the same as the film and the DCS Pro Back, 1/30 at f/11.

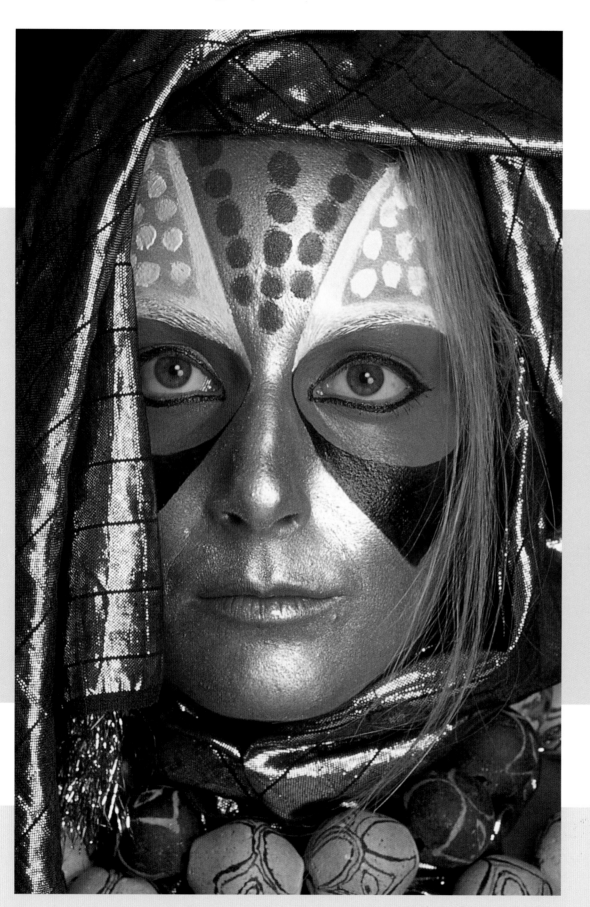

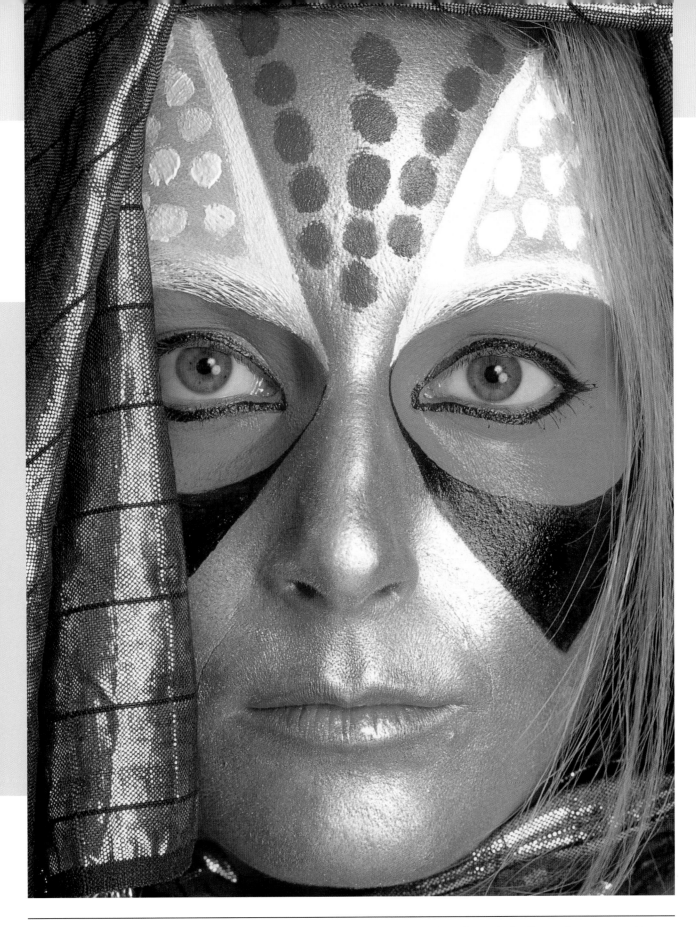

Made under the same conditions as the picture opposite, this photo was altered in Photoshop, which offers endless opportunities to have fun with a colorful image such as this one.

A 4x5 output of a shot taken with the D30 shows some further experimentation in Photoshop. This software opens so many new avenues to explore, Barry feels he hasn't even scratched the surface yet.

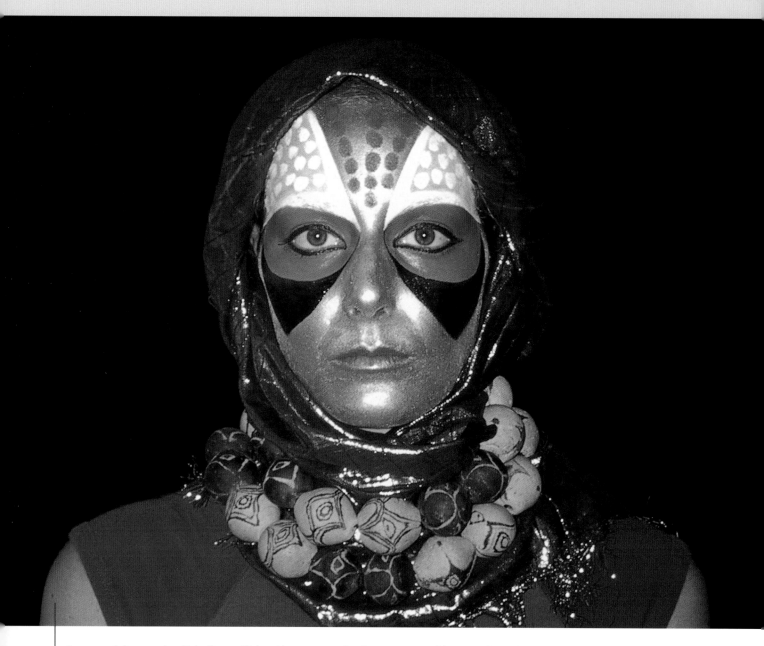

Barry used the amazing little Canon Elph, with its tiny strobe that pops out of the top. About the size of the smallest cell phones, it's very easy to carry around in your pocket. It comes with an 8MB CompactFlash card, but he recommends buying a larger flash card. He carries several of the 128MB flash cards for use in the D30. Nikon, Minolta, Sony, and others all make comparable models, which are considered low-resolution digital cameras.

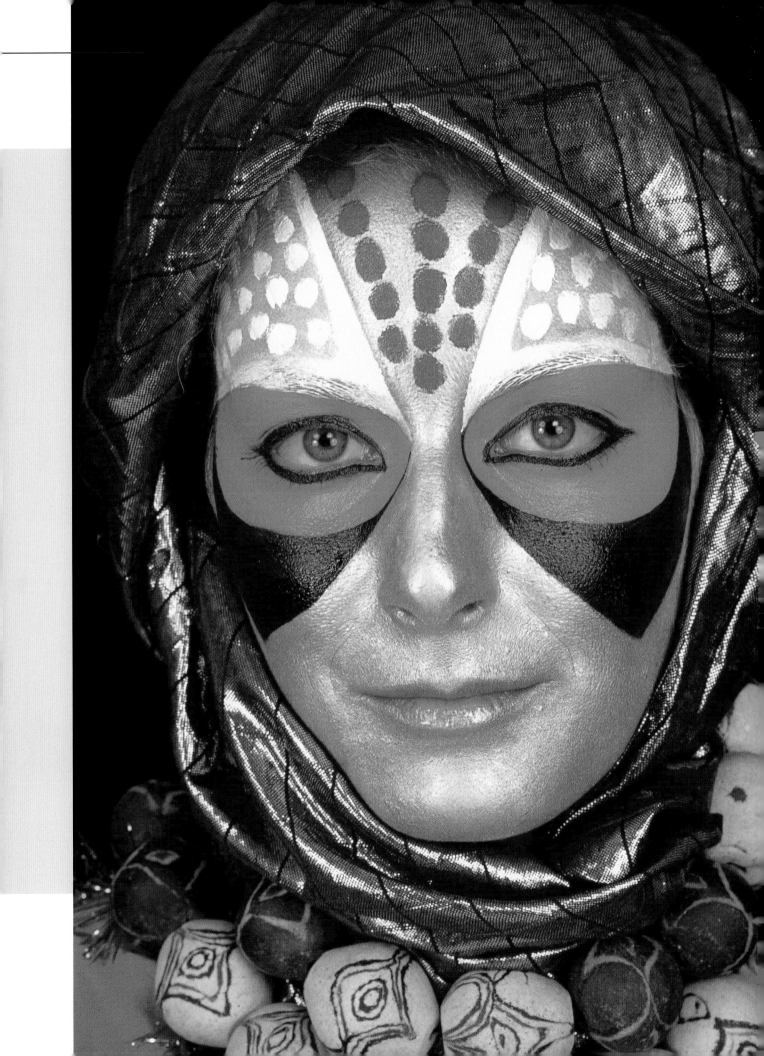

girlfriend

Invisible Bonds, Enduring Ties

Commercial and
Editorial Angles

Professional photographers spend most of their early careers finding a style, putting together a portfolio that reflects this style, and honing their creative abilities so they can instantly produce an idea or a direction for a photograph. Unfortunately, the commercial photographer must work for a client; thus, sadly, just when photographers have finally reached the point when they can contribute the most, they are asked to contribute the least. Shooting sessions can become needlessly complicated when the decision-making process involves an entire committee from the client.

Such constraints are more prevalent in the advertising end of commercial work than the editorial, which is why many successful advertising photographers will always accept editorial assignments. Because an inherent part of the advertising in the beauty and fashion fields is to show what's new and exciting in current trends, these areas generally allow the photographer more creative input than commercial advertising. Nevertheless, editorial work still affords the greatest photographic freedom. Editorial art directors are often willing to try something new because they have to deal with the same subjects every month, especially in women's magazines. Since art directors of major consumer magazines don't have to answer directly to a client, they have the advantage of being innovative without fear of losing the account. Their aim is to provide visual variety and they count on the photographers, illustrators, and designers to contribute creatively.

The disparity in financial arrangements between advertising and editorial work is often ludicrous. It is not unusual to create a shot for a magazine that would have brought perhaps ten times more if it were an advertising job. Many photographers are willing to stretch the budget for a chance to work on something visually exciting, since editorial art directors are usually responsible for starting new trends in photography.

Before embarking on an assignment, be sure to have some ideas about the possible uses of what you are planning to shoot. This requires research on your part, as well as paying attention to your editors. When shooting stock, take advantage of simple settings to create different situations during the same session. A few minutes devoted to changing props can dramatically increase your chances of getting many saleable photos without having to change backgrounds, location, or lighting.

Product Advertising

Photographers involved in product advertising must often contend with a number of constraints. Aside from concerns over type placement, horizontal or vertical format, and other restrictions based on the layout, the client may introduce other worries. Will the model present the right image for the product, or will her good looks overpower the product in the final ad? Is the shot too sexy, or too plain? Every photographer encounters these problems at one time or another. But sometimes a client has the intelligence to trust the photographer's good sense, both practically and visually. The photographs shown here are the result of working with just such clients.

The control over the look of an advertisement belongs to whoever is writing the check. The production and creation of that look should be in the control of the ad agency art director or designer. The actual execution of the look is finally given to the photographer, who many times is the last person to become involved. This is unfortunate, because it limits the photographer's ability to contribute more to the photograph than just the technical execution. As a professional photographer, Barry feels he's hired to solve photographic problems for the client. And solving these problems involves a knowledge of composition, exposure, and lighting, all working together to create the effect the client wants.

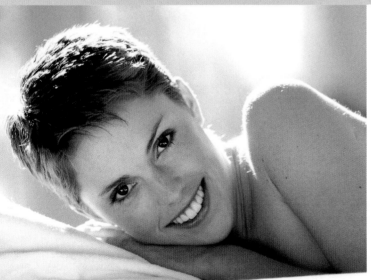

Instead of encumbering a shoot with strobes, stands, power packs, cables, and umbrellas, Michael always tries to use natural light first. During a two-day studio shoot with Sara Stover he was able to change backgrounds and lighting often to make the best use of natural light. They started with Sara, wearing a white robe, in front of north-facing glass doors. To balance the warm golden background light from the south-facing doors and windows, Michael placed four 4x8-foot white panels far enough from the shadowed side of the studio to reflect direct sunlight through the north-facing doors and provide a soft main light for Sara.

For the second shot Sara lay on a mattress, placed near enough to the south-facing windows that direct sunlight hit the back of her head. Michael added two white reflectors, one on each side of Sara's face. The direct light bouncing off the white sheets, pillow case, and reflectors added enough fill to create a pleasing, natural-looking shot. To give the photo a different look, Michael changed to a higher-speed, grainier film stock.

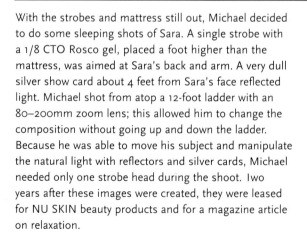

Now dressed as a college student, Sara sat a desk about 20 feet from the background, still at the south end of the studio. Although direct light illuminated the pine armoire behind her, the sunlight did not carry far enough to bounce light onto Sara's face. To provide a main light source, Michael placed a strobe head with a 1/4 CTO gel over it on a light stand slightly behind Sara. The strobe head was aimed at the back and side of Sara's head and a 4x8-foot white reflector was moved in on the left side to bounce the direct light from the strobe back into her face.

With the strobes and mattress still out, Michael decided to do some sleeping shots of Sara. A single strobe with a 1/8 CTO Rosco gel, placed a foot higher than the mattress, was aimed at Sara's back and arm. A very dull silver show card about 4 feet from Sara's face reflected light. Michael shot from atop a 12-foot ladder with an 80–200mm zoom lens; this allowed him to change the composition without going up and down the ladder. Because he was able to move his subject and manipulate the natural light with reflectors and silver cards, Michael needed only one strobe head during the shoot. Two years after these images were created, they were leased for NU SKIN beauty products and for a magazine article on relaxation.

Many photographers think that once the sun sets the show is over, but in fact some of the most beautiful light can occur twenty minutes before or after sunset. Just after a session in which Michael was shooting Kathy in a white swimsuit at the ocean, he noticed a beautiful soft light and pastel background created by the setting sun passing through the high summer haze. At Michael's request, Kathy donned her white cotton bathrobe, grabbed a jar of moisturizer from her makeup bag, and pretended to apply it to her face. Michael set the 180mm lens at f/2.8 to put the ocean and sky completely out of focus. Because moisturizers are aimed at keeping skin healthy and beautiful, he sells many photos of women featuring such products.

Michael originally created this shot of Lisa Stimmer (see pages 122–23) for stock. Citizen Watches later purchased it for a national advertising campaign.

An enticing photo such as this one could be used to sell any number of beauty products. To achieve this shot, Michael positioned an antique makeup table and mirror so that a reflection of the fireplace would be visible in the mirror. He arranged the table with antique perfume bottles, lace tablecloths, fresh flowers, and an incandescent table lamp fitted with a 100-watt bulb, and he asked Kathy to do her hair and makeup as if she were going out for a night on the town. Next to the table lamp, a strobe head in a small lightbox was directed at Kathy's face, providing facial illumination and also containing the light so it wouldn't overbrighten the room. He mounted the camera with an 85mm lens and set the shutter speed to 1/8 sec so the flames from the fireplace and light from the lamp would register on the film. The long exposure added warmth to the lightbulb, giving the feeling that the scene was lit solely by the table lamp.

For several years Barry has been working with Dannon Yogurt, a wonderful client. This series of shots was made with Hannah Hardaway, a mogul skier from the Olympic Ski Team, which Dannon co-sponsored. After some research, Barry determined that shooting on the slopes at a 10,000-foot altitude would not be practical, so he rented a studio in Denver and had a snow set built. Working in a studio allowed much greater control of lighting, hair, and makeup, as well as the very precise position of the hand holding the product. The art director and Barry both knew they couldn't light properly for the product and a beauty shot at the same time, so they decided to reshoot the product later in the studio to match the position of the product in the selected shot. This approach is not unusual, especially nowadays with the advantages of Photoshop.

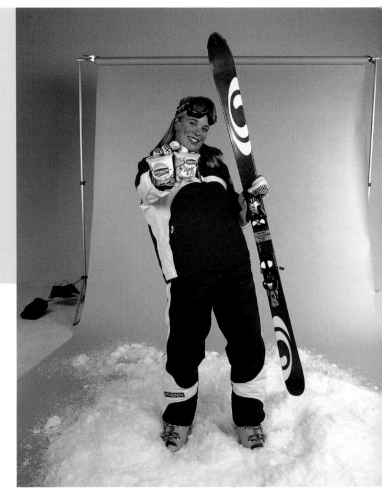

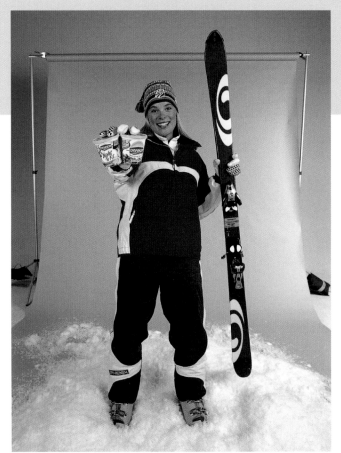

Hannah was a trooper! Not only as pretty as most models, she was also very professional and showed understanding about the technical problems. Barry used the Mamiya 6x7 Pro with a 50mm wide-angle lens to carry the focus of Hannah and the skis. Each shot was done twice. Hannah would flash her knockout smile and then freeze position; for the second shot Barry would quickly refocus on the package so her hand and fingers would be sharp for the Photoshop change of the product. The primary shot became a full length "standee" in stores throughout the country and additional shots were used in promotional ads.

Hannah finished fifth at the Olympics in Salt Lake City. She admitted that she didn't ski her best that time, but promised, "I'll be back in 2006 in Italy!"

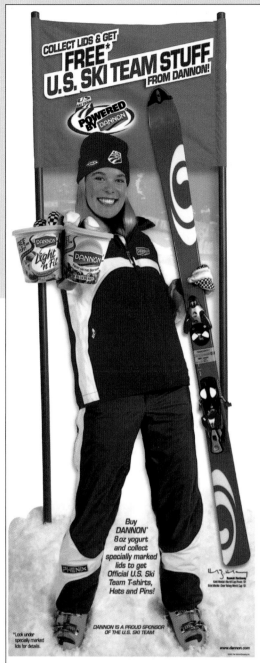

Editorial Glamour

A lot of editorial work takes place on location. Editors often like to add interest to a beauty feature by using a new resort or a particular type of setting as a background to the piece. It works out well for everyone: the magazine gets an interesting feature, the hotel or local tourist board gets national advertising, and the crew gets to work in pleasant surroundings.

The greatest advantage to working on location is that these jobs are among the most creatively flexible type of professional assignments. Editorial assignments will have a theme or direction that the magazine wants you to follow, but there's almost always room to improvise. It is up to the photographer to come up with some sort of cohesive approach that illustrates the idea of the feature most effectively.

If you're not selecting a background color according to a client's specifications, there are many methods by which to make your choice. Barry often decides to wing it and go with whatever the moment suggests. He keeps a large selection of standard seamless backgrounds in the studio, as well as a number of canvases created just by splashing paint on them; a dropcloth also works nicely for this. Sometimes Barry may try to match the background color to a model's eyes or eye shadow or garment, but again it's a visual judgment made at the time without particular preplanning. Having a number of options on hand will encourage you to experiment and learn what works best for different situations.

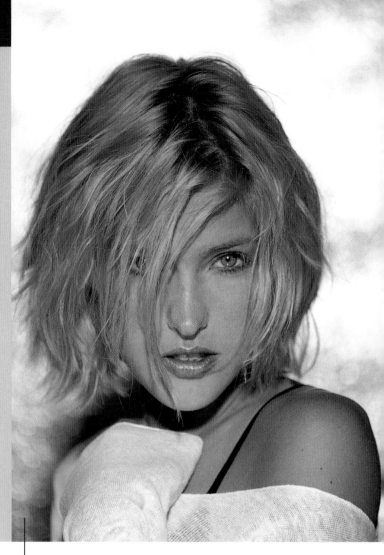

Barry hit this hot silver textured paper background with the main light, a DeSisti 1200-watt HMI spot/flood light.

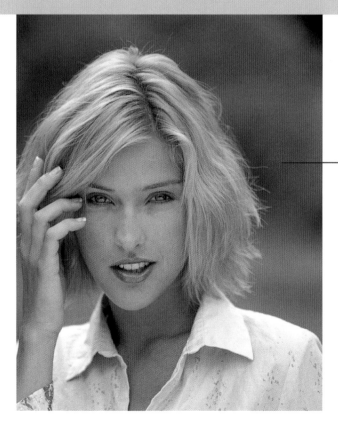

These cover tries of Kelley, a model with Click Models in New York, incorporated various film, lighting, and wardrobe changes. Kelley enjoyed going through all her looks, from pouty to big smiles. Barry asked her to do her hair and makeup as if she were going out clubbing in the city. All the shots were made with the Canon EOS1V, and most used the Canon EF 180mm f/3.5 L macro lens. This "before" shot was made in the open shade with a white FlexFil held about chest level.

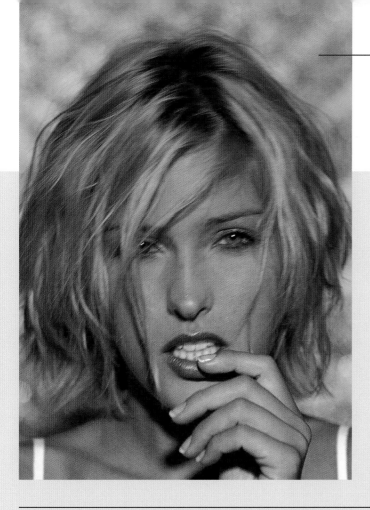

Again using the HMI light on full spot, Barry placed Kelley in front of a magical background and shot with Kodak E100s film. He loves this sparkly greenish Mylar material (which he found at an industrial plastics supplier) because each type of light source seems to change its color.

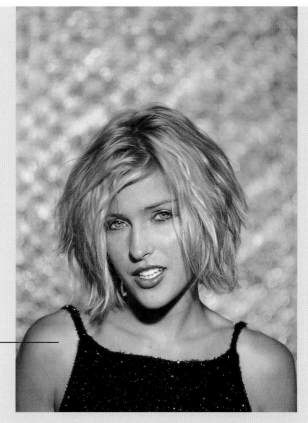

Here Barry turned off the HMI and switched to the Canon EF 100mm f/2.8 macro lens in order to use the Canon Macro Ring Lite MR-14EX with Kodak E100SV for added saturation, made at f/8.

Still using the 180mm lens and the HMI, Barry switched to Kodak 160T, tungsten film that he rated at 125ASA for a washed-out look.

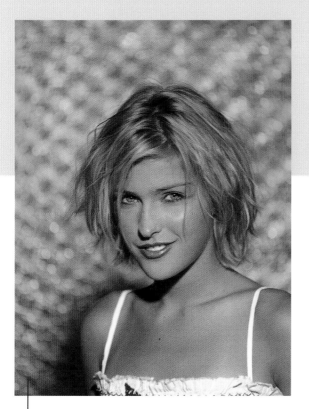

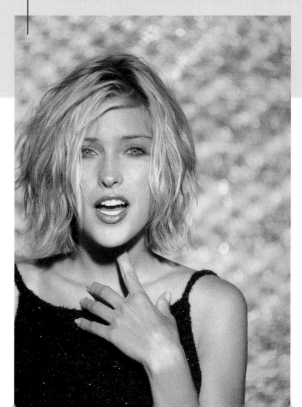

After Kelley made another clothing change, Barry returned to the 180mm lens and E100S and the HMI.

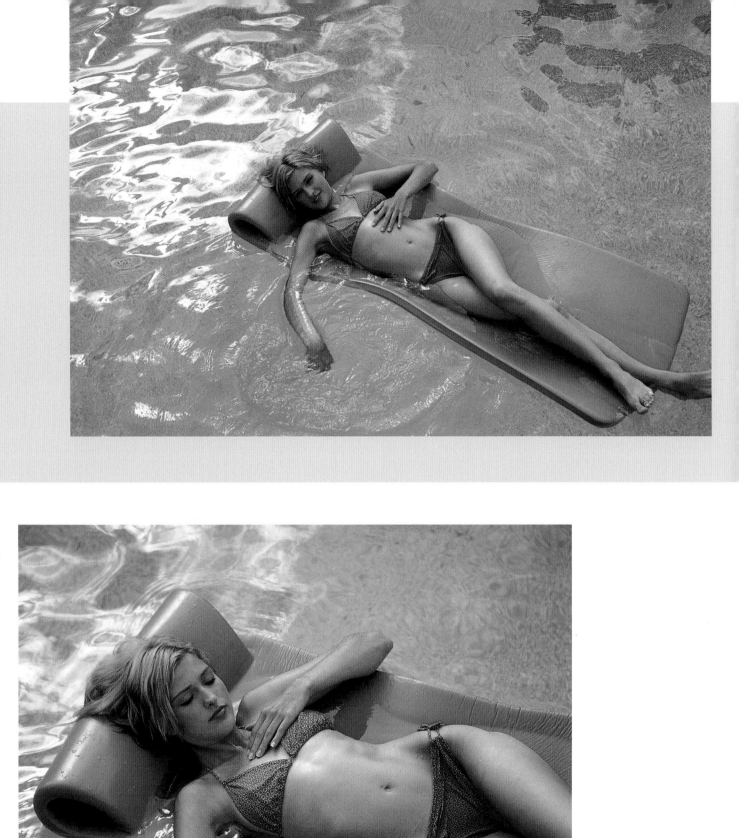

After a long photo session, Kelley took a break at the pool—but Barry kept right on shooting! The high sun was overcast but without backlighting, so Barry worked from this direction to pick up the water reflections and lessen the chances of Kelley squinting. He used the stabilized 28–135mm Canon lens on the EOS-1V and handheld the camera to make it easier to keep her in the frame. The stabilized lens provides the equivalent of having about two extra seconds—in other words, if you're shooting handheld at 1/30, the stabilized lens gives the effect of shooting at 1/125.

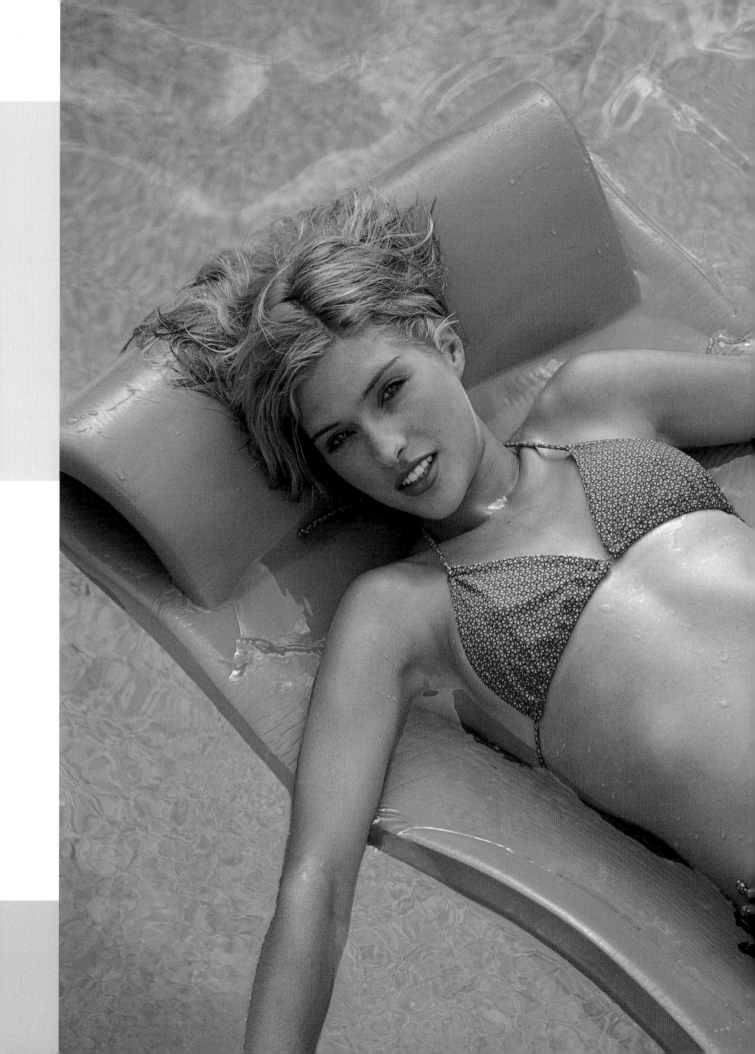

A flash of a lacy black bra, a sudden glimpse at a sexy little garter, a wet white t-shirt, a plunging neckline or a touch of leopard? What will make your hottie take notice? *Let's dish.*

dressed to thrill

Sexy Little Style Secrets to Make Him One *Very* Happy Camper

By Graham Masterton

YOUR WILDEST DREAMS

Oh, the lust, the sex, the steamy moments you experience in your bedroom...all of them after you've fallen asleep! What do all those erotic dreams mean? Plenty!

The alarm clock rings, and you groggily come to life, a warm, fuzzy, satisfied feeling lingering over your body. Like you've just had the most incredible sex. You think back to what generated such heat and a big grin spreads across your face when you remember the dream. As you jump in the shower, you start dissecting your little sleeping fantasy. What did the dream mean?

In her book, *Dreaming Your Real Self: A Personal Approach to Dream Interpretation*, author Joan Mazza, M.S., reveals all those hidden layers and meanings. Here, *Complete Woman* shares the most tantalizing of facts.

WHY WE DREAM ABOUT SEX
A sudden increase in sexual dreams might occur for some people when their sex lives have improved or they have a new and exciting partner. An increase in sexual activity will make the subject of sex and sexual images more prominent in your mind, and therefore in your dreams. Many people say that having sex (especially after a hiatus) increases their sexual desires, and this, in turn, results in dreams that are more sexual in nature.

On the other hand, if you're going without sex, don't have a partner or have an unwilling or undesirable one, your dreams might be compensating for

COMPLETE WOMAN

Michael photographs many couples and single women in bed, and the images usually wind up in magazines for articles on human sexuality. This photo of Kathy Murphy was made with three different light sources. Michael placed a light foam mattress on the floor, 6 feet from sliding glass doors through which natural diffused light was streaming. A strobe head on a boom stand was aimed at the top of Kathy's head with the tungsten modeling light on. The main light was placed on the floor, aimed at her face and adding a nice little punchy catch light to the eyes. A white diffuser over the strobe's reflector diffused the light so as not to overpower the natural light on the mattress and the tungsten hair light. He set the 85mm lens at f/2 at 1/30 sec. Eight months later a woman's magazine purchased the photo.

Michael can shoot from dawn till dusk—and usually does. This is exactly what happened on a stock trip to Miami Beach, where he spent the day capturing a model doing various things: having breakfast, working out, writing letters, putting on makeup, talking on the phone, and so on. They began with an image of her waking up. Michael aimed two strobe heads at the white wall by her feet and placed white reflector cards very close to each side of her face. Neutral-density gels over the strobe heads lowered the light output level to achieve an exposure of 125 sec at f/1.4, allowing very shallow depth of field. He used an 85mm lens, trying to shield it to avoid lens flare. The little bit of flare actually added more softness and lowered contrast to produce a very flattering photo, which he later sold to a woman's magazine for an article on dreams.

Always on the lookout for a great stock shot, Michael snapped this during a session and later sold it to *Time* magazine for a dynamic cover photo.

Early in his career while on location in Hawaii, Michael would spend every evening photographing the glorious setting sun with the largest telephoto he had. He would sometimes wait for vacationers to be part of the composition, and since they were shown in sharp silhouette, no model release was needed. This is one of the many photographs from that time that he has repeatedly sold for travel brochures and advertisements.

A Favorite Model

Barry and Michael have both shot with Lisa Stimmer during their careers and found her to be a consummate pro, and one of the most talented models they know. At the age of forty she still looks as good as she did when she first started out. She also has certification in nutrition, personal training, and lifestyle counseling, and has studied natural gourmet cooking. Athletically inclined her whole life, she can wind surf, roller blade, juggle, ride a unicycle—the list goes on. She even graced the cover of Barry's book *Hot Shots: How to Photograph Beauty that Sells* (Amphoto, 1992).

Michael's first session with Lisa was for a department store swimsuit catalog shot in Bermuda more than fifteen years ago. Since then they have worked together for assignment jobs and stock production. They make a point to get together every six months to bounce around photo ideas, shoot stock, and create new images to keep her portfolio current. Over the years she has become his best-selling body and face model who has always been extremely helpful to him and the other models on all his shoots.

Michael set a large white beach umbrella on its side to reflect light to Lisa's face and took a number of shots utilizing a few simple props. He stresses the importance of taking a little time beforehand to think about what you are going to shoot and devoting a few minutes to changing props. That way you increase the chances of creating many saleable photos without having to change backgrounds, location, or lighting, which in the long run will save you valuable time that you can devote to other shots.

When the afternoon sun made its appearance, Michael set Lisa up in a hammock strung between two trees. Shade blocked Lisa from the direct sun, and all Michael had to do was place a white reflector card under her feet to reflect light onto the soles. He added a whimsical touch with two small yellow flowers between her toes. He shot with an 85mm lens at f/8.

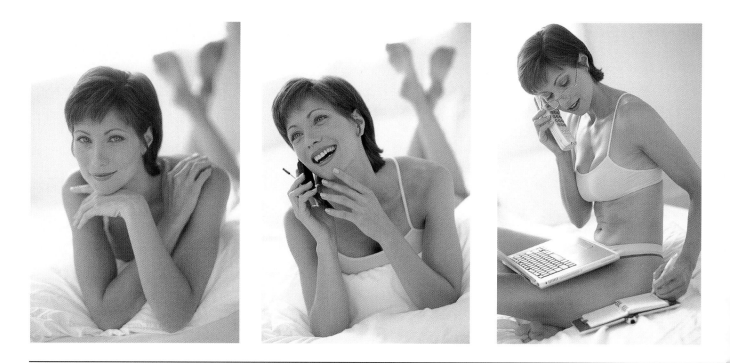

On a heavily overcast day, Michael set up lights for some studio shots. He placed a strobe outside the studio, aimed at the window behind Lisa, with a 1/4 CTO gel to simulate sunlight. A sheer white curtain over the window diffused the direct strobe, and two 4x8-foot white flats in front of Lisa bounced light back to her face.

This is one of the many stock shots of Lisa that Michael later sold to a national ad campaign.

The Lighthearted Approach

In thirty-five years of professional photography, Barry never has so many laughs and such a wonderful time producing images as he does when working with Tom Connor and Jim Downey. These extraordinary and (Barry insists) slightly mad raconteurs and idea people are the originators and writers of an extremely successful series of parodies that have already sold over four hundred thousand copies each. Barry credits the success to the way Tom and Jim set up the relationship with the publishers, retaining complete creative control, with no editing of their copy or his images. Thus their company, Southport Beach Productions, was able to turn over to the publisher a complete package: copy, images, layout, and design.

With the exception of Suzy, who played Martha, all the other models featured throughout the three books were friends and acquaintances. After seeing a large number of models at a casting session, Tom and Jim immediately knew that Suzy was the one as soon as she walked in. They sent her out to buy a wig and have her hair salon cut it to the proper specifications. Throughout the several years of productions, Suzy has been terrific and a great sport!

The cover for the trio's first parody, "Is Martha Stuart Living?" played on the idea "how to dominate a tag sale." This shot, like so many in this series, was a major production. They gathered props from all their homes and staged the battle in front of the barn at Barry's studio. To the left of the set, to diffuse the sunlight, Barry placed a 12x12-foot silk on a Mathews portable frame held in place by Mathews high roller stands. White 4x8-foot foamcore reflectors were placed on each side of camera position. He used Kodak E100S film 120 for all the covers. He generally uses the 35mm format, but chose the 6x7 because it is ideal for cover shots.

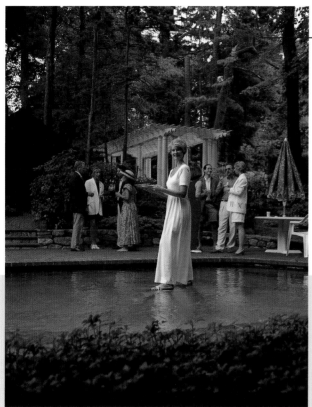

This was the first cover attempt for "Martha Stuart's better than you at Entertaining"—a shot of the hostess walking across the surface of her swimming pool to serve guests. The canopy of trees around the pool presented Barry with the problem of open shade and basic top light. He knew the DeSisti 1200-watt HMI spot/flood light was not powerful enough to fill the face, but he made the shot anyway. A large hemlock at the southern end of the pool created an unforeseen problem, so Barry had to shoot fast as the shadow started to creep up the dress. He used the Mamiya RZ 6x7 Pro II with the 140mm lens. He usually uses 35mm format but the 6x7 is ideal for covers.

Barry was quite pleased with the location for the cover of "Martha Stuart's Excruciatingly Perfect Weddings." He had total backlighting, with white reflectors surrounding the camera.

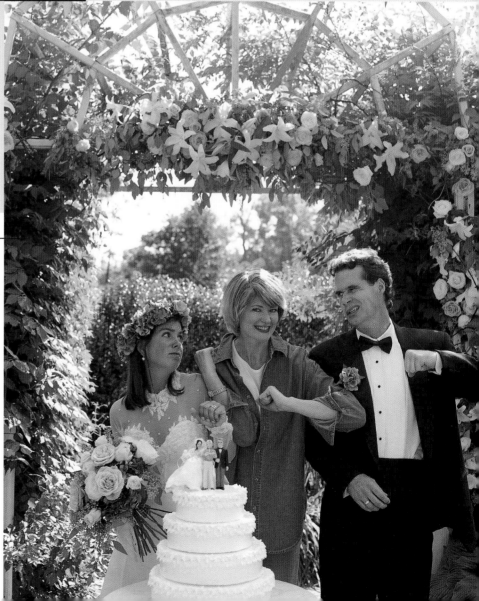

Suzy poses as Martha in one of many photographs made over a period of several years.

In an "at home with Martha" image, Barry lit the scene to appear as if the fireplace was the main light source.

OPPOSITE: Dressed as the "dominatrix of domesticity," Suzy/Martha was lit with a single silver umbrella for a slightly hard look, and the shadow was retained for effect.

To have "Martha" appear to walk on water, two 4-foot aluminum stepladders were placed in the pool so they were just under an inch below the surface. Suzy got into position with the help of long planks. Here Tom and assistant Brian help Suzy as Jim offers a guiding hand from the water.

Couple Dynamics

Although the major emphasis of this book is on photographing women, there are many occasions when the beauty photographer will be asked to photograph couples. A male model is often added to a beauty or fashion shot as "window dressing," an additional prop to add interest to the setting.

The most important part of working with couples is casting. This goes beyond the obvious choice of hiring two good-looking people. If you have to work with a couple to convey a close relationship, it is best if they can relate to each other. Nothing is more difficult than trying to work with two people who can't stand to touch each other. When shooting couples, photographers often insist on being involved in the final model selection to be assured of working with two people who can project an image of a warm relationship.

Some of the most terrific female models in the business have trouble working with a man because they are used to doing singles. It becomes impossible for them to share the spotlight. When you put two people together, you want people who will naturally touch, laugh, talk, gesture, or display any of the normal reactions anyone would have when placed in these situations. Whether it's walking on a beach, having a drink, or simply standing around talking, if the contact is forced, it will look false to the camera.

These shots illustrate the tremendous versatility and adaptability of experienced models who know how to create believable relationships on their own through years of working to the camera. Almost no directing was needed other than picking out the location and an occasional suggestion to turn one way or the other or look into the lens. They project this to the camera without any direction beyond the initial instructions describing what the photographer is trying to convey.

Sometimes more than just faces have to look beautiful. Barry's friend Bobby Hudson is the busiest male hand model in New York. When shooting hands, Barry always keeps the light source at least 45 degrees away from camera center, otherwise the back of the hand can look pretty "hammy." Since the heads were so close together here, soft fill was needed directly above the camera.

A number of professional models also have other full-time occupations. Some just got started later, some were introduced to modeling through a friend, and some just never wanted to be exclusively a model. Peter and Dale are both successful in their respective careers; he is a real estate agent and she is also an actress and spokesperson. This was shot with Agfa Scala using a Canon f/1.8 85mm lens and available light.

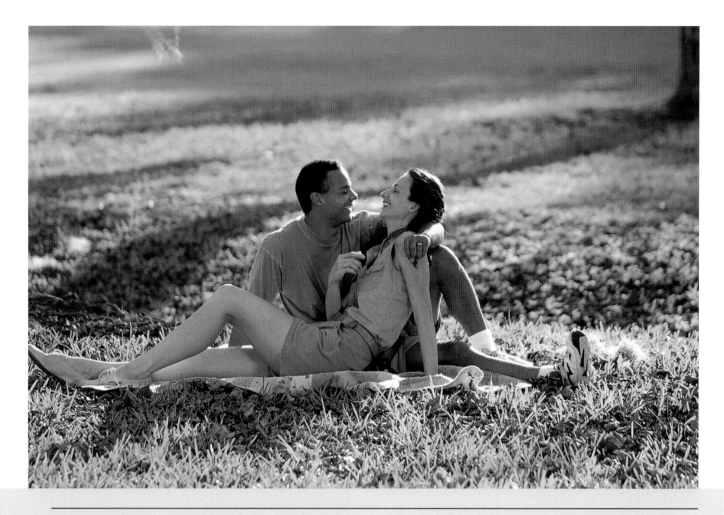

A modeling agency in Orlando supplied Barry with a multiracial couple, the Armstrongs. For a late afternoon shot in a small park in downtown Orlando, Barry wanted a very subtle fill, so he placed several white reflectors flat on the ground in front of the couple, just out of camera.

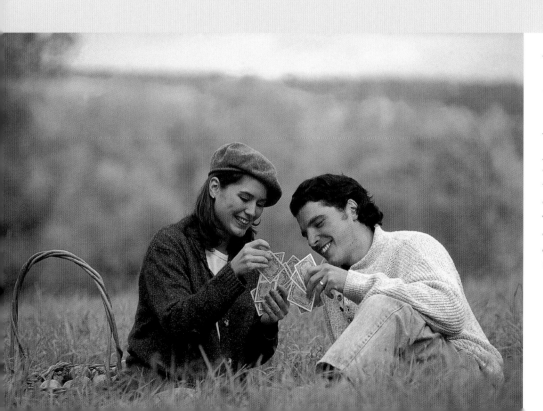

Michael wanted to take advantage of the lovely fall foliage at his property, so he took some couples shots of model/actor/spokesperson Tanya Memme and model/actor Jay Michaels. He gave them a deck of cards and asked them to have fun playing a game. Since it was cloudy, all he needed were two white reflectors, one on each side of the models, to reflect the softly diffused light from the overcast sky back to them.

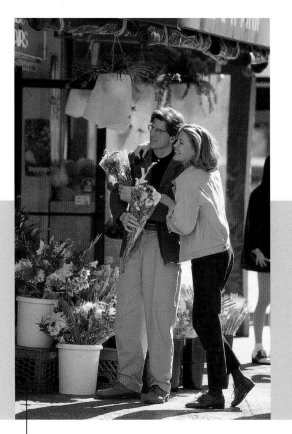

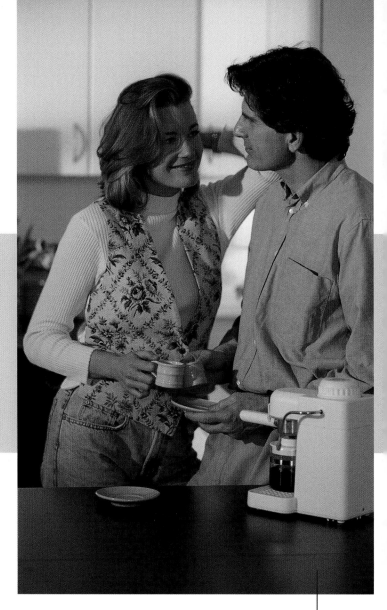

Betsy and Phil needed little direction from Barry to look like typical New Yorkers enjoying the shopping on upper Madison Avenue. As they strolled, Barry walked backwards and shot, with an assistant walking in front of him so he wouldn't bump into anything. He finds the autofocus of the Canon EOS-1N and 1V ideal for this type of shooting, and he used the Canon f/1.8 85mm fixed-focal-length lens.

When Barry finished shooting Betsy's loft-living session (see page 69), he added a male model to the scene for some couples shots. He used the HMI with 1/2 CTO for a late-afternoon effect.

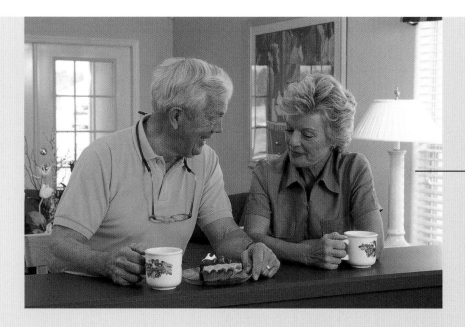

For an image of a retired couple in Orlando, Barry relied on a favorite location-scouting trick. When he needs a generic interior, he looks for a new development of houses or condos. The model home is usually decorated nicely and the builder is often happy to trade usage for a couple of shots.

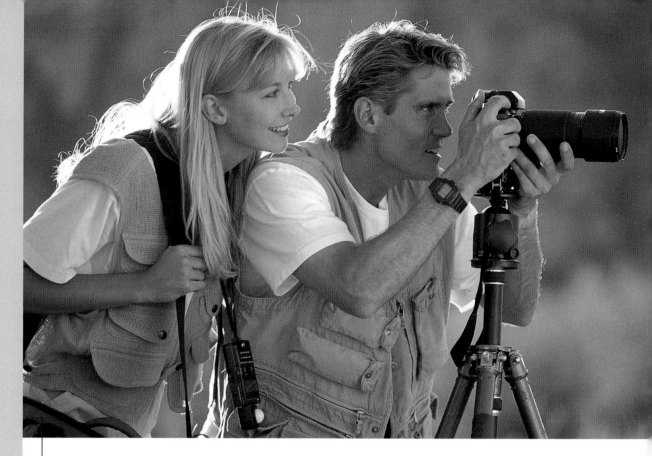

When Michael visited Christine Westlund (see pages 54–55) at her home in Arizona and met her boyfriend, Dan, he knew he had to get some shots of the two of them. He called horseback-riding stables, river-rafting expeditions, and hot-air ballooning companies and set up barter arrangements to shoot them doing a whole list of exciting things that could sell in stock. At one point Michael decided they looked like photographers on a photo safari in Africa, so he gave Dan most of his equipment as a prop while he shot them handheld with an 85mm lens. He parked the white van just to the left to act as a reflector.

Tom Fitz began as a New York City Policeman but eventually became so busy as a model that he quit the force to devote full time to modeling. After twenty years of working together, Barry knows that Tom can always play to his female counterpart, in this case Susan. This late-afternoon shot was taken with a long lens and an 81A warmup filter to counteract all the green.

Here Tom Fitz poses as an New York City executive. Barry loves shooting on the streets of the city because so many film and TV productions take place all the time that blasé New Yorkers give little notice to still shootings.

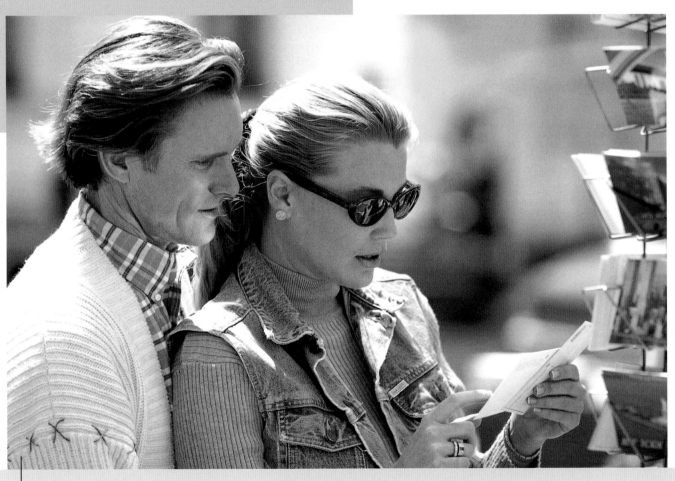

Betsy and model Michael pose on Fifth Avenue, buying postcards. Barry used the Canon 300mm f/4 set wide open to blur the background completely.

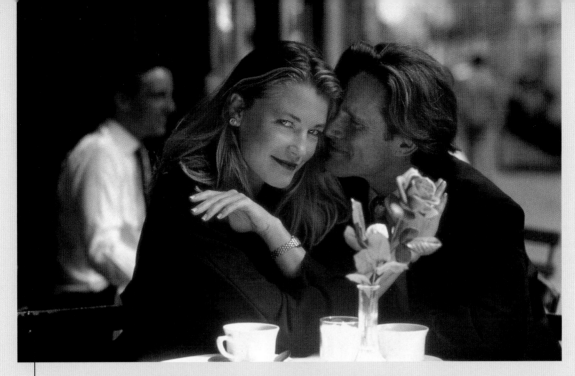

At a sidewalk café, Betsy and Michael play a romantic couple. The sun bouncing off the white tablecloth lent an almost soft-box effect.

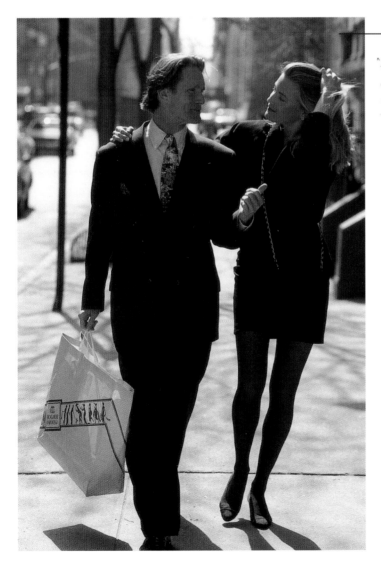

Betsy and Michael stroll along Madison Avenue as if they've just been shopping. Barry used the same camera setup as in the picture of Betsy and Phil on page 130, again walking backward and shooting while the models interacted.

When Michael arrived at Stillmeadow Farms to shoot Tanya Memme and Jay Michaels, the noon sun was too strong, so they looked for a shadier setting. The property—owned by Michael's neighbors Richard and Bernice Roessing—had an old hay barn that was just the right setting. He moved the hay bales to make better use of the beautiful light coming in the barn doors, and put a 4x6-foot white reflector card to the right of Tanya to bounce light into her face. Michael stresses the importance of studying your location before you begin shooting to find the best possible background and light.

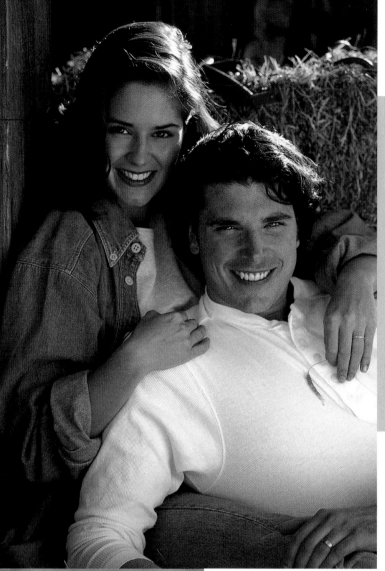

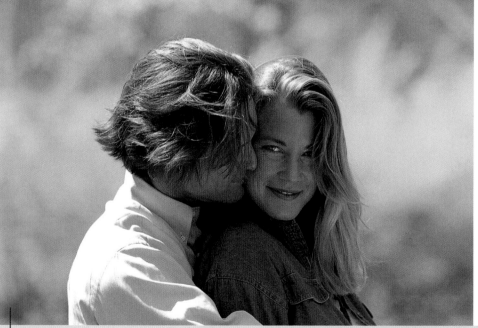

Betsy and model Michael play a couple relaxing in Central Park. An assistant held a 6-foot white Flexfil.

OPPOSITE: Model John Guidera poses with Josette on a sunny beach. Michael's assistant held a white beach umbrella above the models to soften the light.

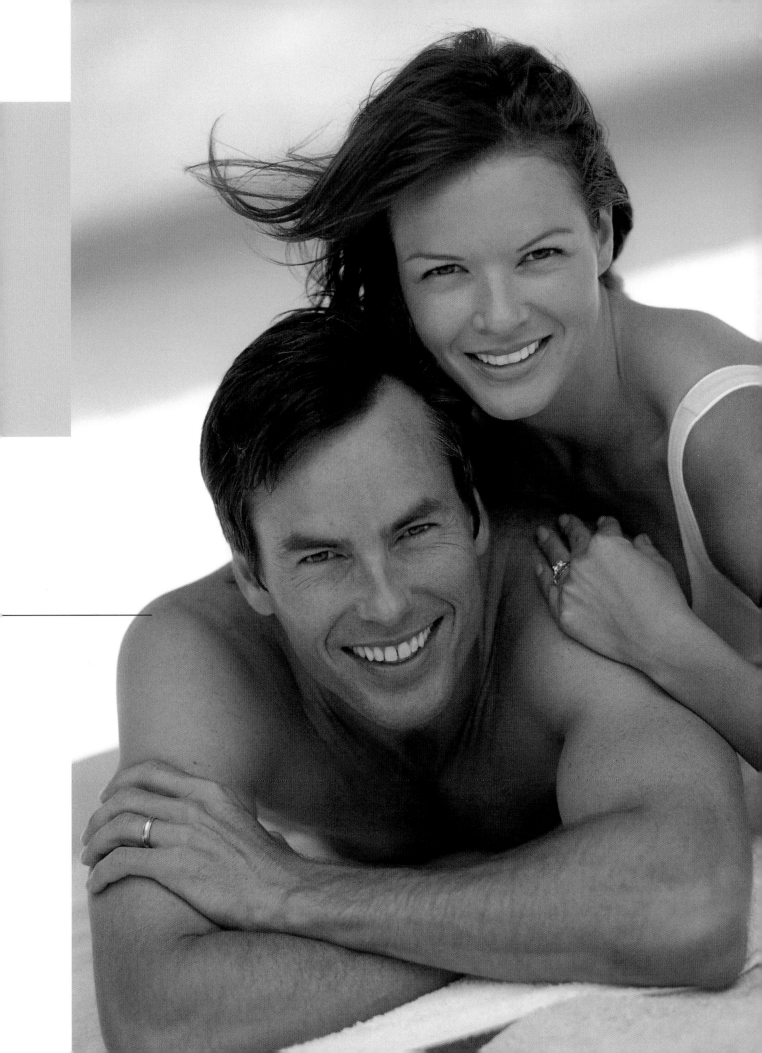

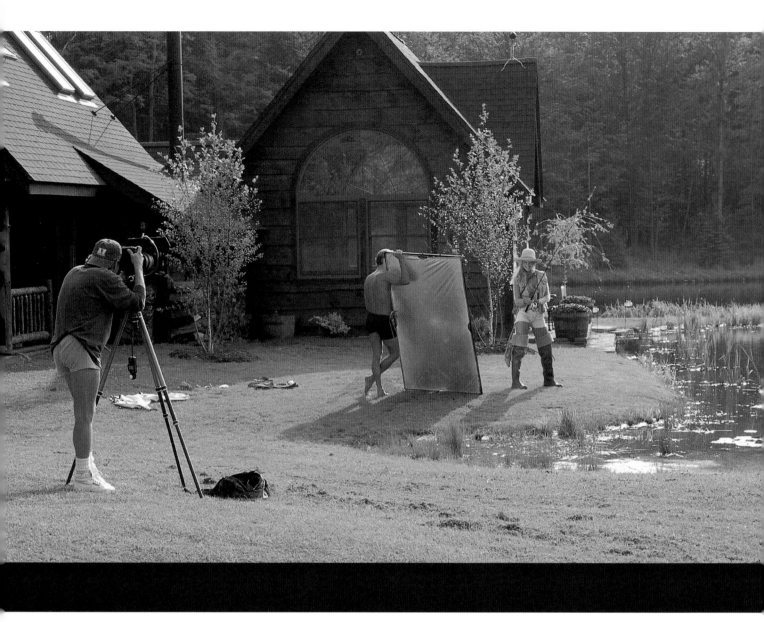

The Country
Studio

Early in his career, Michael determined to keep his working environment as enjoyable as possible. When he visited his good friend photographer Roy Morsch and his wife, Joanne, at their beautiful country home in rural Pennsylvania, he was inspired to leave the city for a more rural lifestyle. Several pep talks from Roy and Joanne convinced him that with FedEx, UPS, a computer, and a good fax machine, a photographer could still make a great living two and a half hours from New York City.

Eventually he found a beautiful 100-acre parcel in Beach Lake, Pennsylvania. Over ten years he designed and built a house and photo studio with two guesthouses to accommodate models and friends. He does hire day help when working on production or assignment shoots, and he employs local people by the hour when necessary. But he will often take his own light readings and change seamless backgrounds himself, and he truly enjoys spending rainy days in the warm comfort of his studio, scanning images, editing film, or sticking copyright labels on slides while listening to some cool jazz. These simple tasks help him stay connected to the whole process in a way that keeps photography fun.

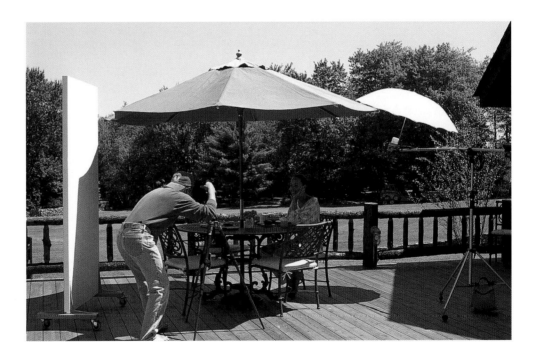

The pond at Michael's studio complex provides a terrific backdrop. Here model Carrie Flaska poses in fishing gear while her boyfriend helps out by holding the reflector. (See page 75 for the resulting shots.)

One of the many benefits of living and working in the country is when a friend like seventy-four-year-old Joe Aue, the former owner of Michael's property, brings over fresh peaches and blueberries for guests and models to enjoy. Joe is always willing to lend a helping hand to hold a reflector, take a light reading, or help carry equipment.

To save time when building sets, Michael usually constructs them around the real windows of his studio and pumps in light from the outside with strobes. He designed the studio with plenty of outdoor electrical sockets to plug in power packs near every window and door.

With its two stocked ponds, swimming pool, open fields, fruit orchards, meadows, and forest, Michael's property provides stunning backdrops for his photography.

Time spent with loved ones remains paramount for Michael, who loves to entertain and prepare meals for guests in the Club Med-like atmosphere he has created at home.

Barry has worked as a professional photographer since 1959. He joined the staff of *Playboy* magazine in Chicago in the early '60s, and in 1967 he relocated to New York City to pursue advertising photography. Handling major productions worldwide for most of the major ad agencies and consumer magazines, he built a reputation as a nonspecialist in a specialist city. In 1981 he became a founding partner of the Stock Market Photo Agency, which grew into one of the most successful stock agencies in the business. (It was sold to Corbis in September 2000.)

By 1994, Barry was ready for yet another career adjustment. Even though he was a partner in a major stock agency, he realized he no longer needed a large New York studio with a full staff and high overhead. He closed the city operation and established a studio in the country. Although at times he misses being in the middle of the action in Soho with all the people coming and going, he now enjoys watching the wildlife pass by the windows—and none of them are rushing to catch the subway!

Barry continues to work for several clients but now turns most of his creative energies toward the fine-art photography market. He believes that all photographers are in the business of communicating with images, ranging from straight portraiture to abstract compositions that reflect personal expression. His favorite thing about the medium is that the photographer is limited only by his or her own creativity and imagination.

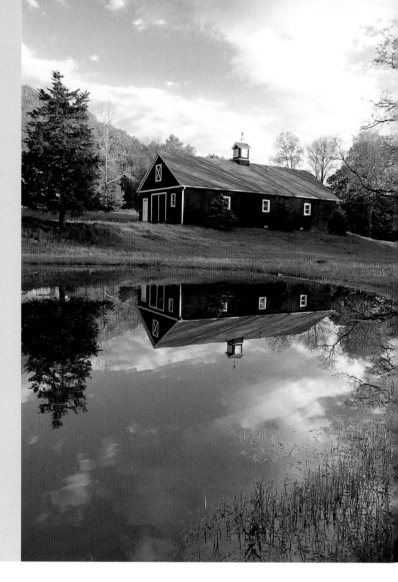

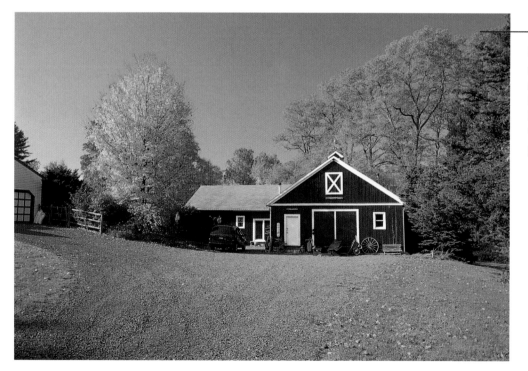

Barry built a 3,000-square-foot studio on a 7-acre spread in the Connecticut woods, because, as he declares, "I have to have some-place to go everyday!"

Barry produced and directed a series of lingerie commercials in the Litchfield County hills of Connecticut, with his studio as a base. The five-day production required a crew of fourteen.

The scale of Barry's studio becomes apparent when a McLaren Mustang is dwarfed by the space. Since the building was once a professional wordworking shop, the floors had been engineered to bear heavy equipment.

Acknowledgments

I would like to thank all the wonderful folks who helped out on this project, particularly the models, the hair-and-makeup artists, the assistants, and the stylists. For their technical advice and support, appreciation goes to Dorian Romer of Kodak, Mike Newler of Canon, and Mark and Kathy Savoia of Connecticut Photographics. Special thanks to Wilhelmina Models of New York City. To my wife Carol, dozens of roses for all the inspiration, help, and patience. Michael and I would also like to thank Amy Handy, our editor, for patiently weaving together two very disparate manuscripts into one very informative book.

— J. BARRY O'ROURKE

Special thanks to Grandma Keller and my mom and dad, for my first camera and helping me set up my darkroom. To Gordon Heath, for recognizing my talents in high school and inspiring me to take them further. To Ed Meyers and Bob Schwalberg, for giving me my first job at *Popular Photography*. To Dr. Christopher Cursio, for providing a safe haven while I perfected my craft. To Roy and Joanne Morsch, who inspired me to shoot stock and find a more fulfilling life and career in the country. To Kathy Murphy and Sandy Roessler, who gave me so much support over the years. To all the models, assistants, stylists, and makeup artists who have helped make my photos beautiful. To Barry O'Rourke, for his invitation to work on this book and for giving me the opportunity to turn my hobby into a profession. To Kyra, my guardian angel on earth, who is always there when I need her most. To Joey Grill at Click Models. And to all the very beautiful women who have given so much to me in life and in front of my camera, I thank you.

— MICHAEL A. KELLER

Index